DISTANCIA A
61 M.

30 M.

21 M.

15 M.

9 M.

6 M.

E

F P

T O P Z

L P E D

E D F C Z P

D E F P O T E C

F D P L T C E O

P E Z O L C F T D

SI NO VE BIEN, CONSULTE AL OCULISTA Y VISITENOS

- If you have bad eyesight, contact the ophthalmologist and pay us a visit. -

- Si vous ne voyez pas clair, prenez rendez-vous chez l'ophtalmo et passez nous dire bonjour. -

CREDITS

GRAPHICS RELOADED / GRAPHISMES REVISITÉS / XATARRA GRÁFICA. Reconstructing the graphic

ISBN: 978-84-936408-1-1
© 2009 PROMOPRESS
© 2009 STARGRÁFICOS

Promopress es una marca comercial de:
Promotora de prensa internacional SA
c/ Ausias March 124
08013 Barcelona (España)
T: (+34) 93 245 14 64 F: (+34) 93 265 48 83
mail: info@promopress.es
www.promopress.info

Idea: Stargráficos
Dirección de arte: Juan Cardosa (www.juancardosa.com)
Diseño y maquetación: Stargráficos
Prólogo: Josep Roca
Traductores: Heather Bagott, Jesús de Cos Pinto, Marie-Pierre Teuler
Imprime: Industrias Gráficas Grup-4, S.A.
Primera edición: 2009
Depósito Legal: B-41.307-09
Printed in Spain

INDEX

Djuna Barnes in the Born (Josep Roca)

||| ENGLISH

Exterior. The Born neighbourhood, Barcelona. Afternoon. A man aged about 40 with a camera stands in front of an old wall. A woman of the same age approaches him.

Woman

Why are you taking pictures of this torn and faded paper?, asks the woman.

Man

I might turn into a T-shirt, a poster, a website... we'll see, answers the man.

Woman

Are you a magician or something? (smiling).

Man

I am a graphic scrap dealer.

Woman

Interesting. My name is Djuna.

Man

Juan. (kisses her on both cheeks).

Interior. Bar. 25 people. The night starts to fall. Djuna and Juan are sitting at a table. She drinks gin; he has a beer. Jazz music.

Juan

For 10 years I've been taking shots in the streets and recovering icons, textures which have changed over time, then I transform them...

Djuna

You transfigure them. (Interrupts him).

Juan

Yes, and I give them a new meaning, a new life...

Djuna

A new soul. (Interrupts again).

Juan

That's right, a sort of reincarnation. And you know what?, I'm going to make a book; I have more than 200 motifs. I want to show the world the transfomations, the transfigurations as you say, that myself and other artists have created from these materials. It also includes a CD with images in Tiff format for people to make their own designs.

Juan talks enthusiastically for half an hour about punk grafism,

dabout Anna Gerber and the Mistake-ism, about David Carson, collage, Josep Renau, John Heartfield, pop art. Djuna finishes her second gin takes out a book from her handbag and gives it to Juan.

Djuna

Here, take this. I bought it just this afternoon. I wrote it.

Juan reads the title of the book: Djuna Barnes: Collected Poems 1911-1982. Then he reads the biography: Djuna Barnes (1892-1982), writer and poet... Leaves the book on the table and looks up, confused. On Djuna's chair there is only a customer's jacket.. He scans the room looking for her. He gets up, takes the book and goes to the bar to pay.

Juan

How much for the two beers and two gins? (to the barmaid).

Barmaid

Two gins...? (surprised). The man that came with you has paid for the drinks already. The two bourbons he had and your two beers. That's right, isn't it..?

Juan smiles and nods. He asks the barmaid for another beer, flicks through the book and reads twice the poem entitled: TRANSFIGURATION.

"The prophet digs with iron hands
 into the shifting desert sands.
The insect back to larva goes;
 struck to seed the climbing rose.
To Moses' empty gorge, like smoke
 rush inward all the words he spoke.
The knife of Cain lifts from the thrust;
 Abel rises from the dust.
Pilate cannot find his tongue;
 bare the tree where Judas hung.
Lucifer roars up from earth;
 down falls Christ unto his death.
To Adam back the rib is plied,
 a creature weeps within his side.
Eden's reach is thick and green
 the forest blows, no beast is seen.
The unchained sun, in raging thirst,
 feeds the last day with the first. "

Djuna Barnes, quartier du Born (Josep Roca)

||| FRANÇAIS

Extérieur. Quartier du Born à Barcelone. Après-midi. Un homme d'une quarantaine d'années armé d'un appareil photo se tient devant un mur qui s'écaille. Une dame du même âge s'approche.

Dame

Pourquoi photographies-tu ce papier-peint défraîchi et déchiré, demande la dame.

Homme

C'est pour en faire un tee-shirt, une affiche, une page web, je vais voir, répond l'homme...

Dame

Tu es magicien ou quoi ? (sourire).

Homme

J'exploite les traces du temps.

Dame

C'est drôle ça. Je m'appelle Djuna.

Homme

Juan. (il l'embrasse sur les deux joues).

Intérieur. Bar. 25 personnes. La nuit commence à tomber. Djuna et Juan sont assis à une table. Elle boit du gin et lui une bière. Musique de jazz.

Juan

Depuis dix ans je photographie dans la rue les images et les textures qui se sont abîmées au fil du temps et puis je les transforme...

Djuna

Tu les transfigures. (elle l'interrompt).

Juan

Oui, je leur redonne un sens, une vie...

Djuna

Une âme. (elle l'interrompt encore).

Juan

C'est ça, c'est une sorte de réincarnation. Et tu sais quoi ? Je vais en faire un livre, j'ai déjà plus de 200 motifs. J'aimerais montrer comment mes amis artistes et moi-même avons transformé, ou plutôt transfiguré, comme tu dis, ces traces. Il contient un CD-ROM avec les images au format TIFF pour que les gens puissent réaliser leurs propres créations.

Pendant une demie-heure, Juan parle avec enthousiasme des graphismes urbains revisités, d'Anna Gerber et du Mistake-ism. Et puis aussi de David Carson, du collage, de Josep Renau, de John Heartfield, du pop art. Djuna termine son deuxième gin et sort un livre de son sac qu'elle tend à Juan.

Djuna

Prends-le, je l'ai acheté cet après-midi. C'est moi qui l'ait écrit.

Juan lit le titre du livre. Djuna Barnes : Collection de poèmes 1911-1982. Il parcourt ensuite la biographie de l'auteur : Djuna Barnes (1892-1982), écrivain et poète... Déconcerté, il repose le livre sur la table. Sur la chaise de Djuna, il y a juste une veste. Il cherche Djuna du regard dans le bar. Il se lève, prend le livre et va régler au comptoir.

Juan

C'est combien pour les deux bières et les deux gins ?
(à la serveuse).

Serveuse

Deux gins...? (perplexe) L'homme qui était avec vous a déjà réglé les deux bourbons qu'il a pris et vos deux bières. C'est bien ça ?

Juan sourit et hoche la tête. Il demande une autre bière à la serveuse, feuillète le livre et lit deux fois le poème intitulé TRANSFIGURATION.

"Le prophète creuse de ses mains d'acier
le sable mouvant du désert.
L'insecte redevient larve,
la rose grimpante redevient graine.
Dans la gorge vide de Moïse s'engouffrent,
telle une fumée, tous les mots qu'il a pu dire.
Le couteau de Caïn ressort après le coup porté,
Abel se relève du sol poussiéreux.
Pilate a perdu sa langue ;
il n'y a rien sur l'arbre où s'est pendu Judas.
Lucifer rugit en décollant de terre ;
le Christ s'enfonce dans la mort.
La côte est replacée dans le corps d'Adam,
et un être pleure enfermé dans son côté.
Les touffus abords de l'Éden verdoient,
la forêt souffle, aucun animal n'apparaît.
Le soleil a brisé ses chaînes et sa soif
inextinguible unit le dernier jour au premier."

Djuna Barnes en el Born (relato de Josep Roca)

II ESPAÑOL

Exterior. Barrio del Born, Barcelona. Tarde. Un hombre
con una cámara fotográfica frente a una pared desconchada.
Una mujer de su misma edad se le aproxima.

Mujer
¿Por qué sacas fotos a este papel roto y descolorido?,
pregunta la mujer.

Hombre
Para convertirlo en una camiseta, en un póster, en una web...
Ya veré, contesta él.

Mujer
¿Eres mago o algo así? (Sonriendo).

Hombre
Soy chatarrero gráfico.

Mujer
Curioso. Me llamo Djuna.

Hombre
Juan. (Dándole un beso en cada mejilla).

Interior. Bar. 25 personas. Empieza a anochecer. Djuna
y Juan están sentados a una mesa. Ella bebe ginebra;
él, cerveza. Música jazz.

Juan
Llevo diez años fotografiando y recuperando de la calle iconos,
texturas, logotipos que el tiempo ha alterado, después los
transformo...

Djuna
Los transfiguras. (Interrumpiendo).

Juan
Sí, y les doy un nuevo significado, una nueva vida...

Djuna
Un alma nueva. (Interrumpiendo de nuevo).

Juan
Eso está bien, una especie de reencarnación ¿Y sabes?, voy
a hacer un libro; tengo más de 200 motivos. Quiero mostrar
en qué hemos transformado, transfigurado como dices tú, este
material yo y otros artistas. También llevará un cedé con las
imágenes en tiff para que la gente haga sus propios diseños.
Juan habla entusiasmado durante media hora del grafismo punk,
de Anna Gerber y del Mistakeism. De David Carson, del colage,

de Josep Renau, de John Heartfield, del pop art. Djuna apura
la segunda ginebra, saca del bolso un libro y se lo da a Juan.

Djuna

Ten, lo he comprado esta misma tarde. Lo escribí yo.

Juan lee para sí el título del libro: Djuna Barnes: Poesía Reunida
1911-1982. A continuación lee la reseña biográfica: Djuna
Barnes (1892-1982), escritora y poeta... Deja el libro en la
mesa y levanta la vista aturdido. En la silla que ocupa Djuna,
sólo hay una americana de un cliente. Barre el bar con la mirada
buscándola. Se levanta, coge el libro y se acerca a la barra
para pagar.

Juan

¿Qué te debo de las dos cervezas y las dos ginebras?
(Dirigiéndose a la camarera).

Camarera

¿Dos ginebras...? (Sorprendida). El hombre que estaba con usted
ya pagó las consumiciones: los dos bourbon que él se tomó
y sus dos cervezas. ¿Es eso, no...?

Juan sonríe y afirma con la cabeza. Le pide otra cerveza
a la camarera, hojea el libro y lee dos veces el poema
que lleva por título TRANSFIGURACIÓN.

"El profeta cava con manos de hierro
En las inestables arenas del desierto
El insecto vuelve a su larva;
Retorna a semilla la rosa trepadora.
Como humo hasta la vacía garganta de Moisés,
Irrumpen todas las palabras que dijo.
El cuchillo de Caín retira la estocada;
Abel se levanta del polvo.
Pilatos no puede encontrar su lengua;
Desnudo está el árbol del que Judas colgó.
Lucifer clama desde la tierra;
Cristo cae a su muerte.
A Adán vuelve la fastidiosa costilla;
Una criatura solloza en su flanco.
La extensión del Edén es espesa y verde;
El bosque se agita, no se ve una bestia.
Desencadenado, el sol, con rabiosa sed,
Alimenta al último día con el primero."

PART
ONE

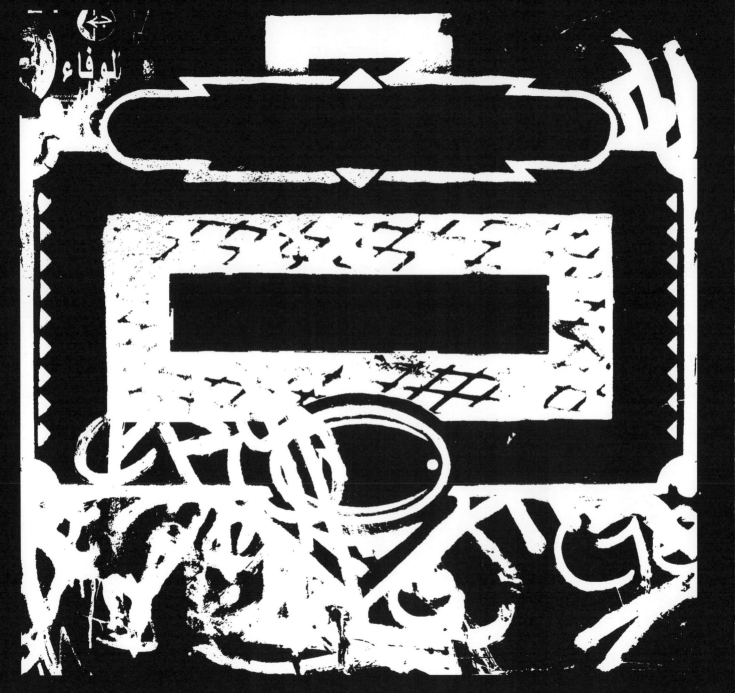

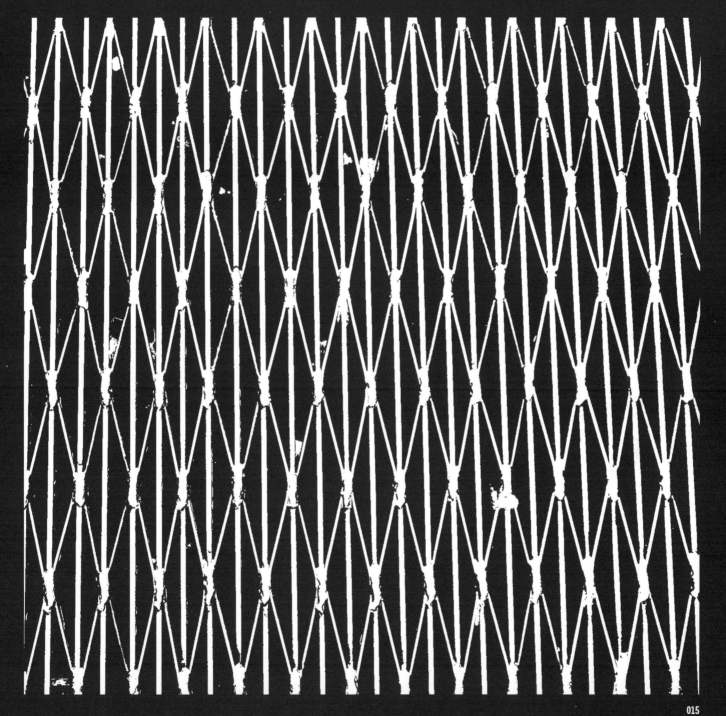

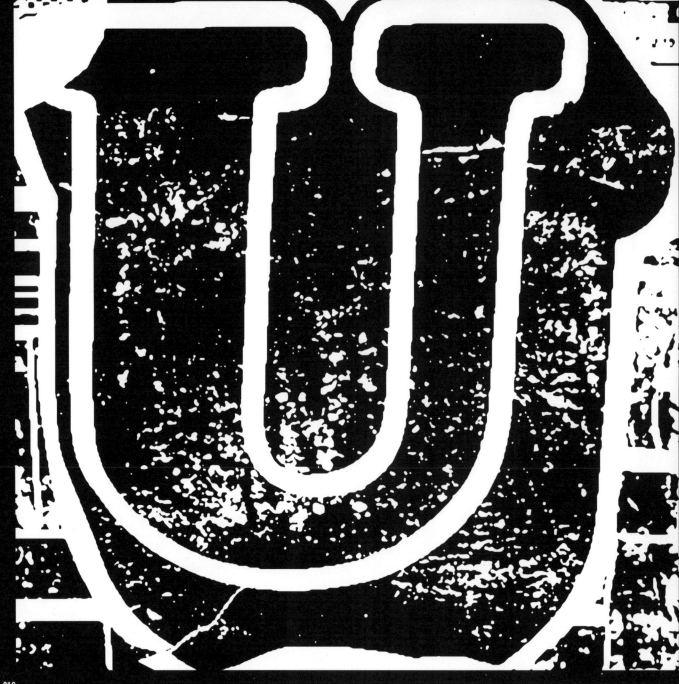

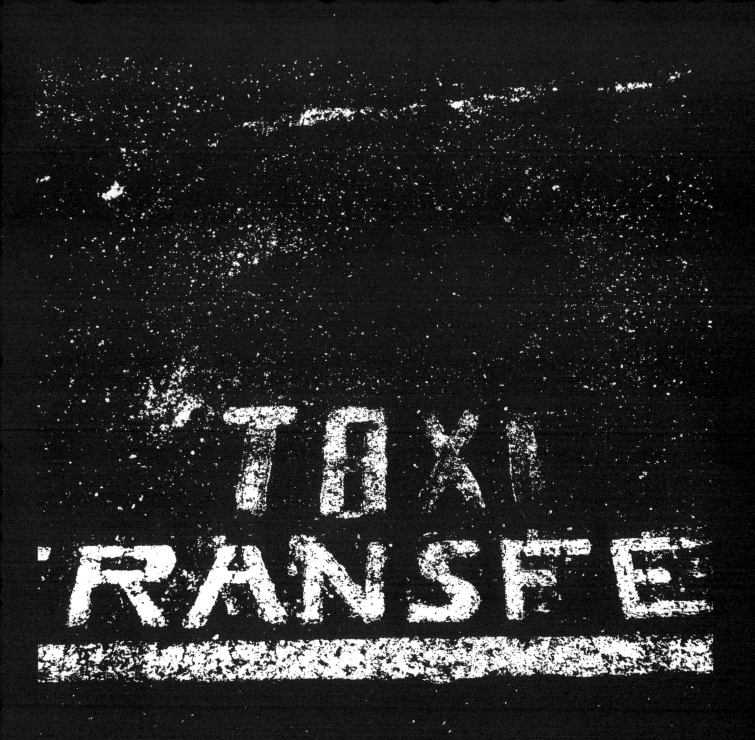

Menù

Potage Guerrillero

Macarones Italiana

Paella

Filet de Buey

Ensalada Variada

Pavo Trufado

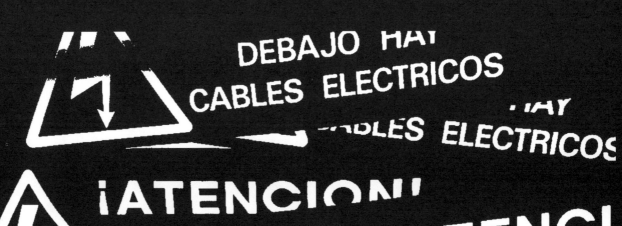

DEBAJO HAY CABLES ELECTRICOS

¡ATENCION!

¡ATENCI

DEBAJO H
CABLES ELECT

¡ATENCION!

DEBAJO HAY
CABLES ELECTRICOS

endesa

CABLES ELECTRIC

¡ATEN

ENCION!

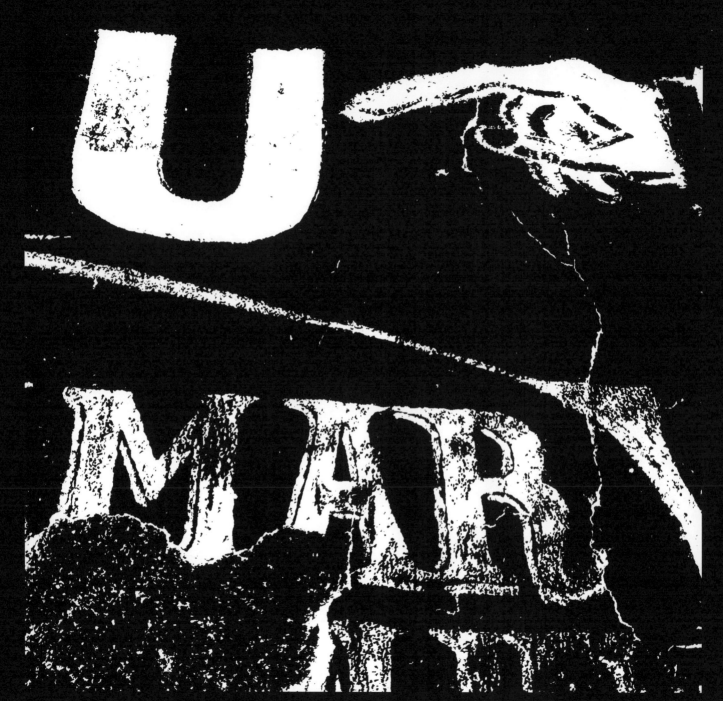

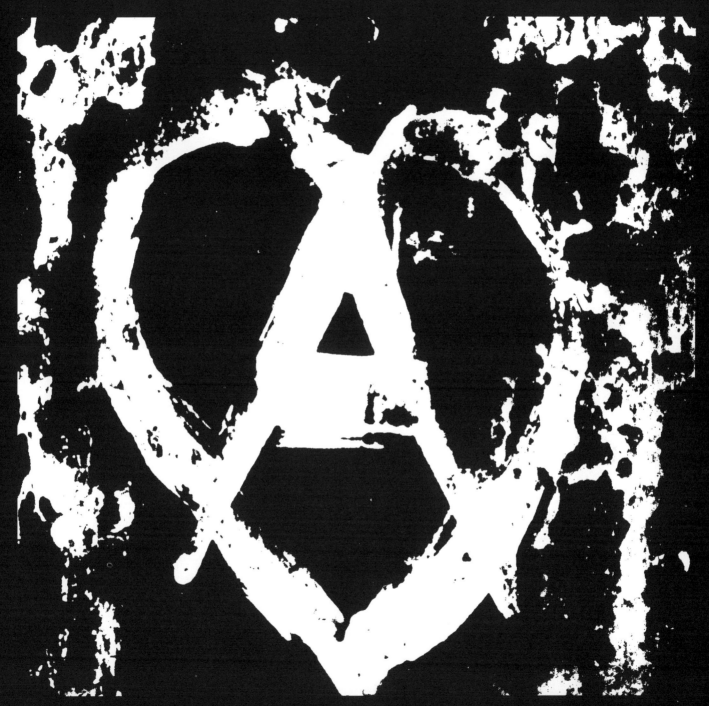

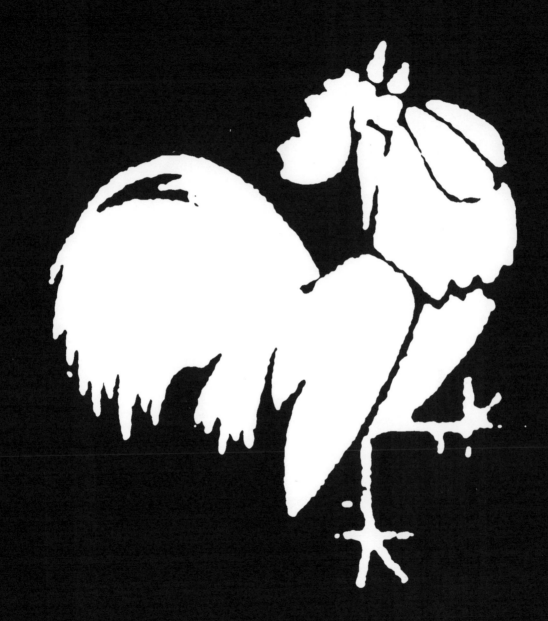

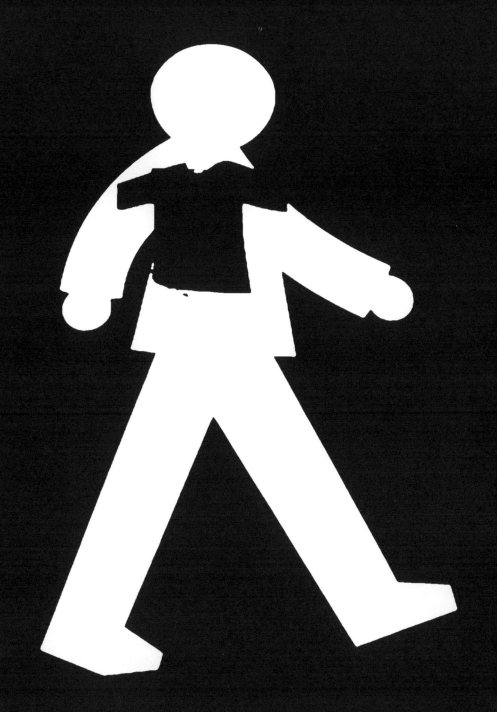

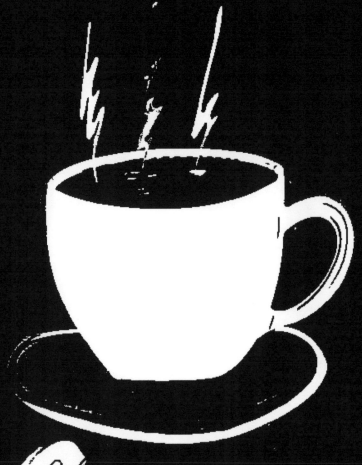

CAFE
EXPRESSO CORTADO

SUPER
OFERTA

027

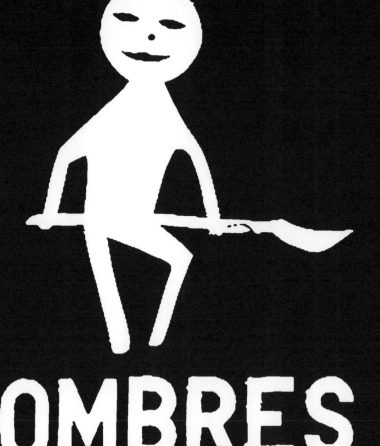

HOMBRES TRABAJANDO

- Men at work. -
- Travaux. -

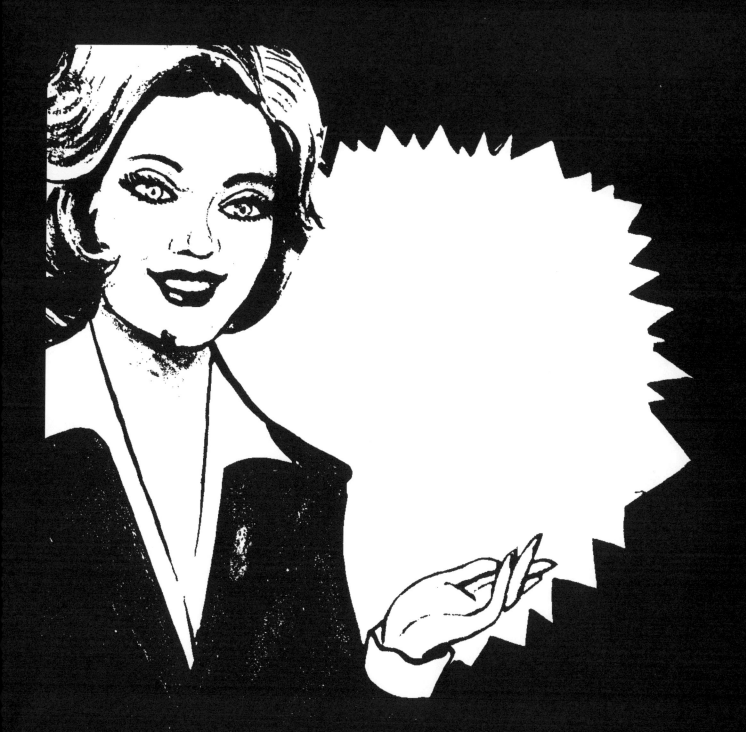

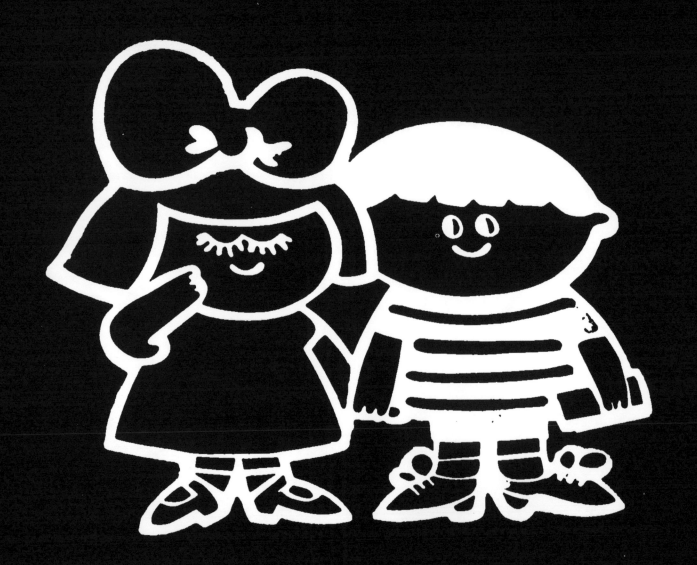

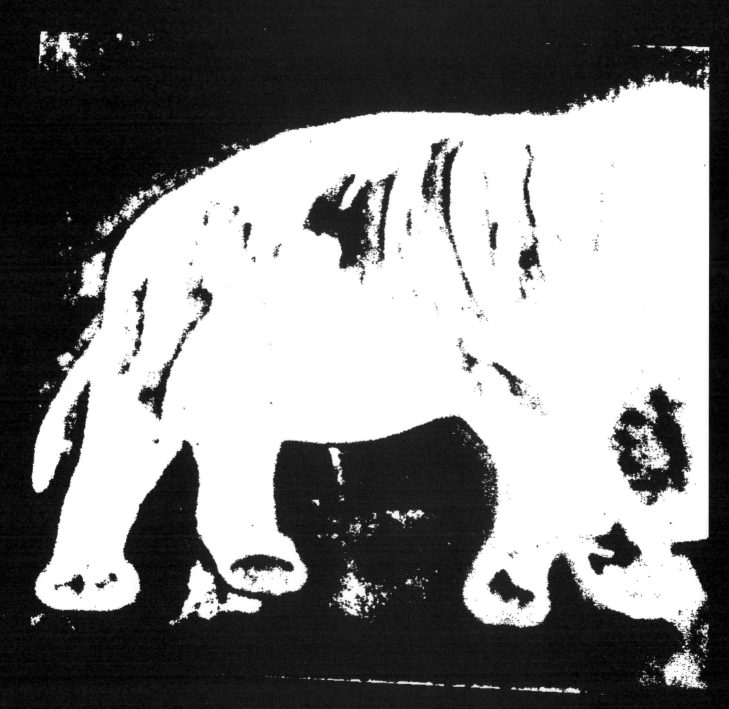

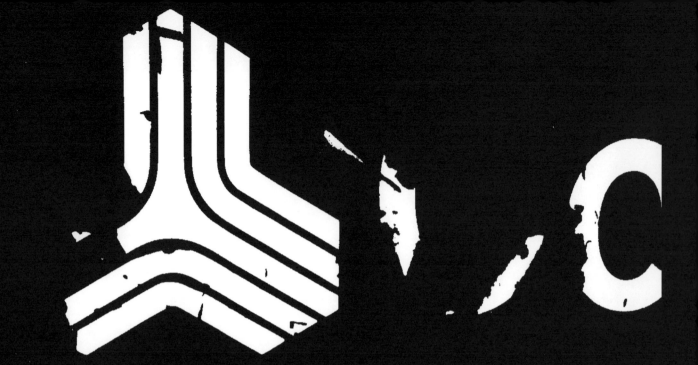

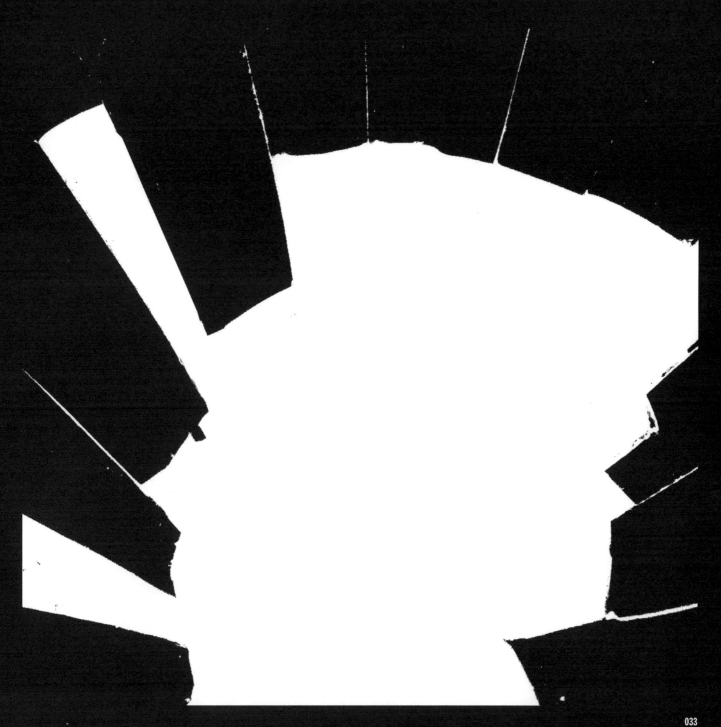

033

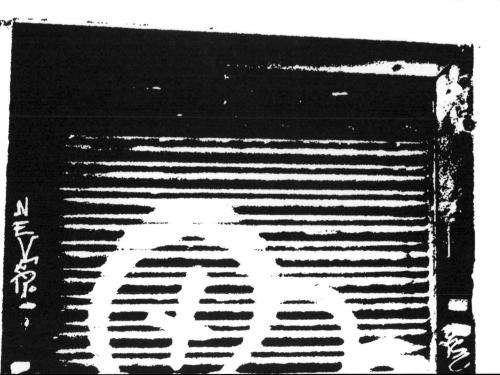

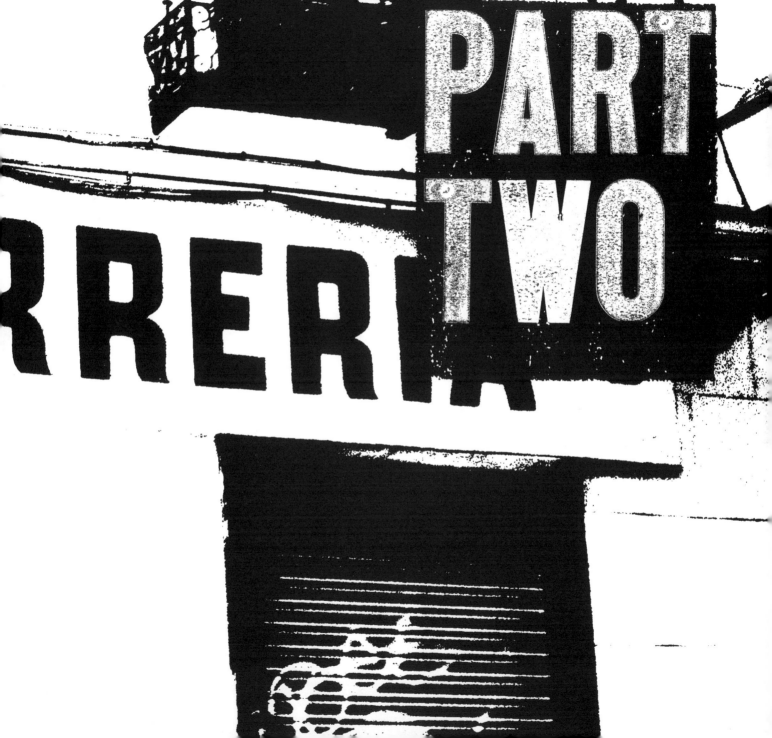

RRER

PART
TWO

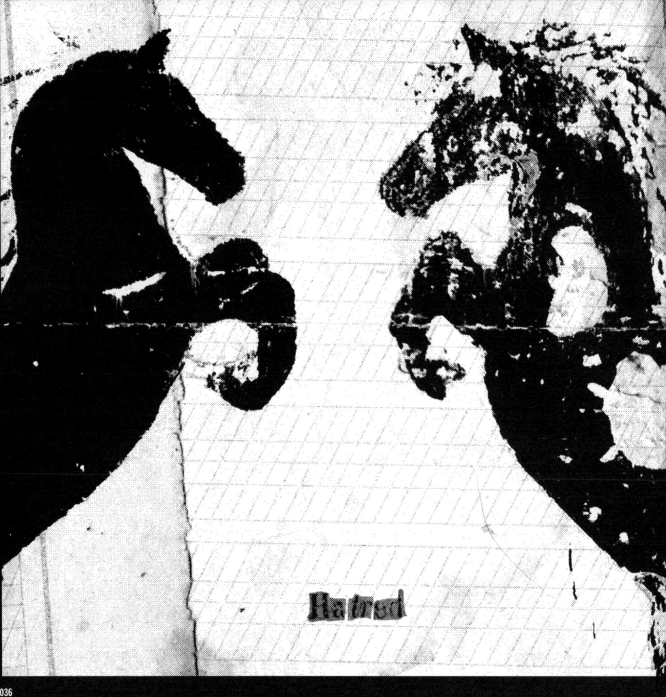

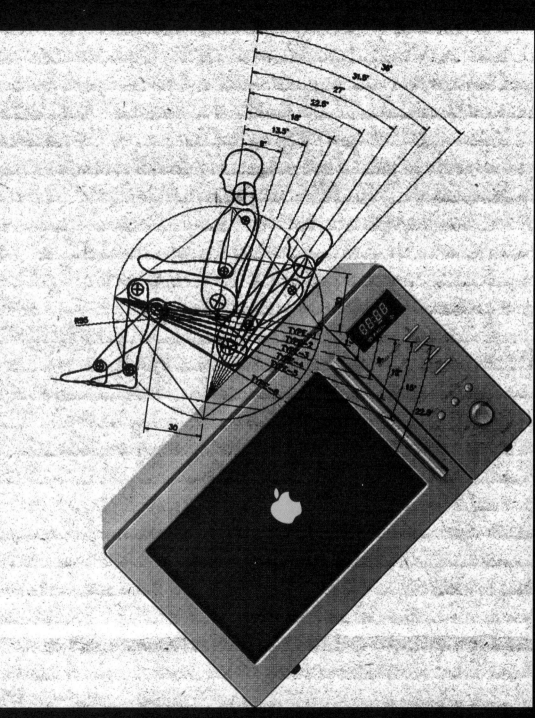

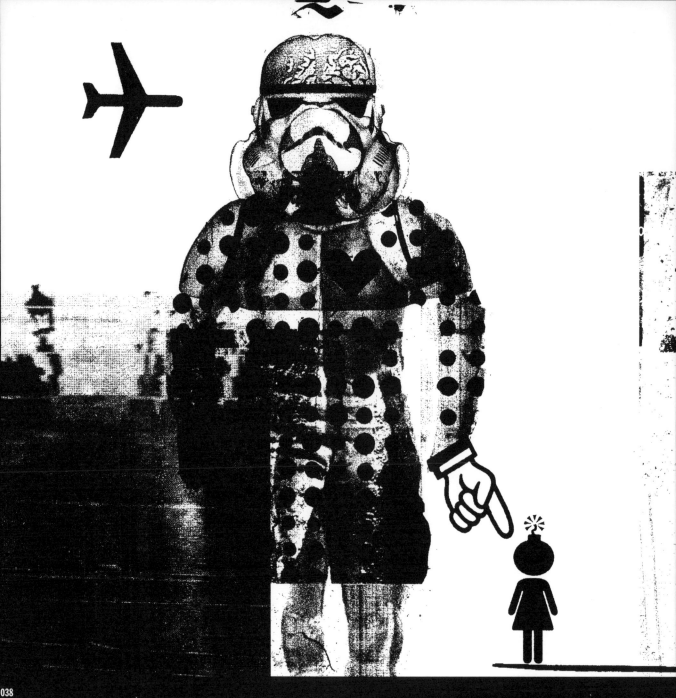

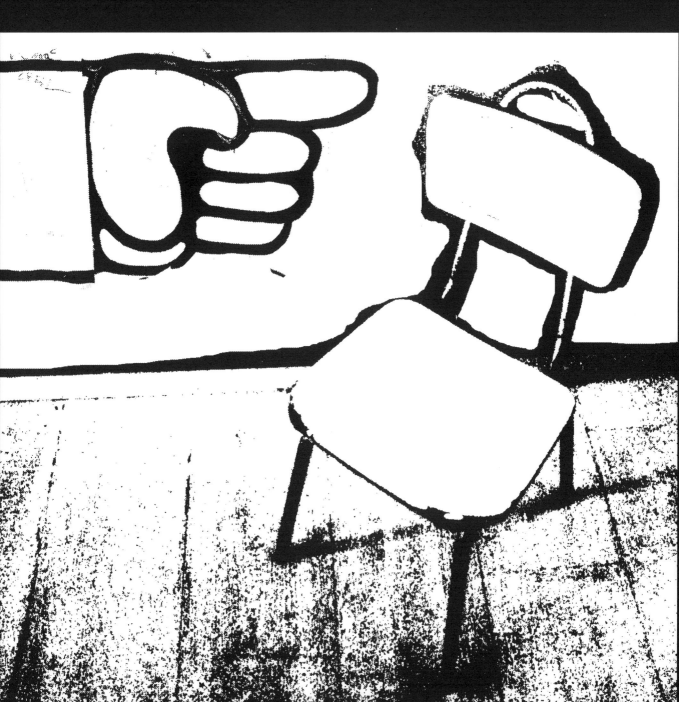

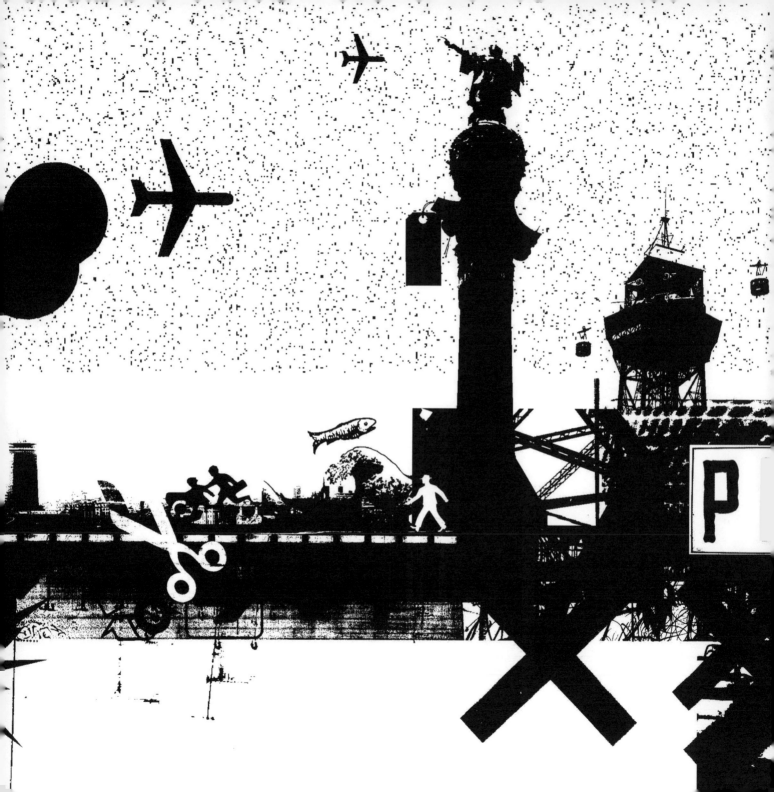

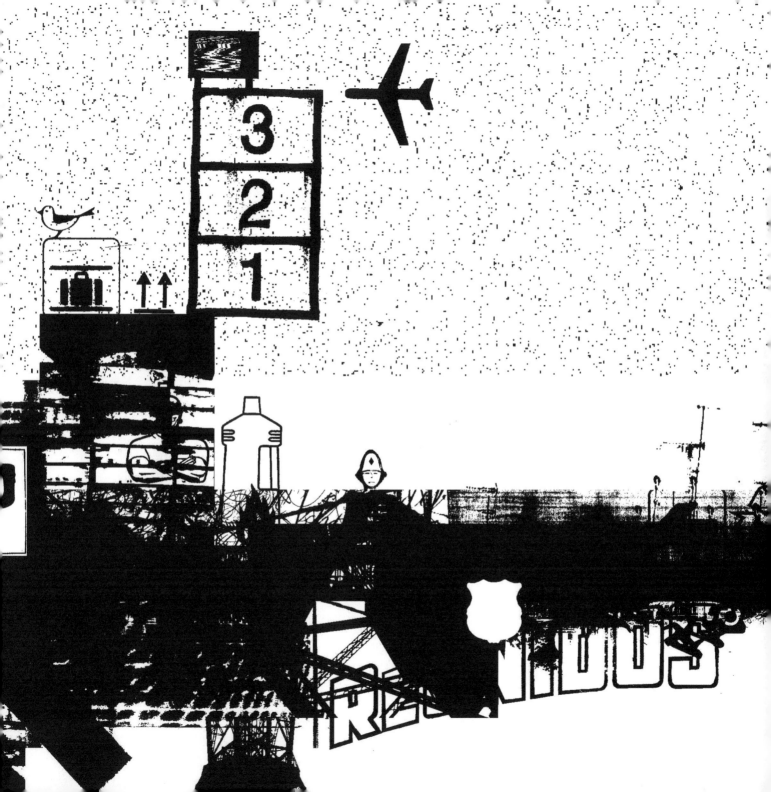

miau!

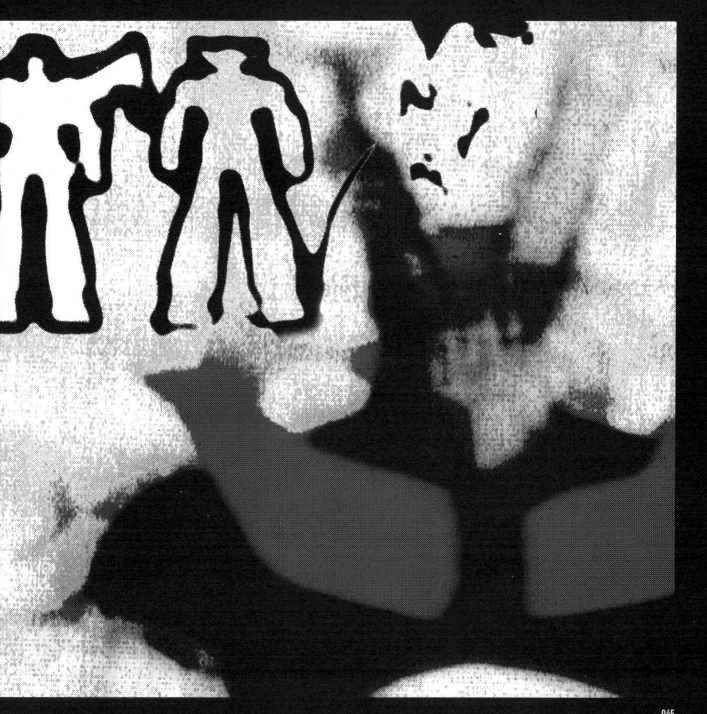

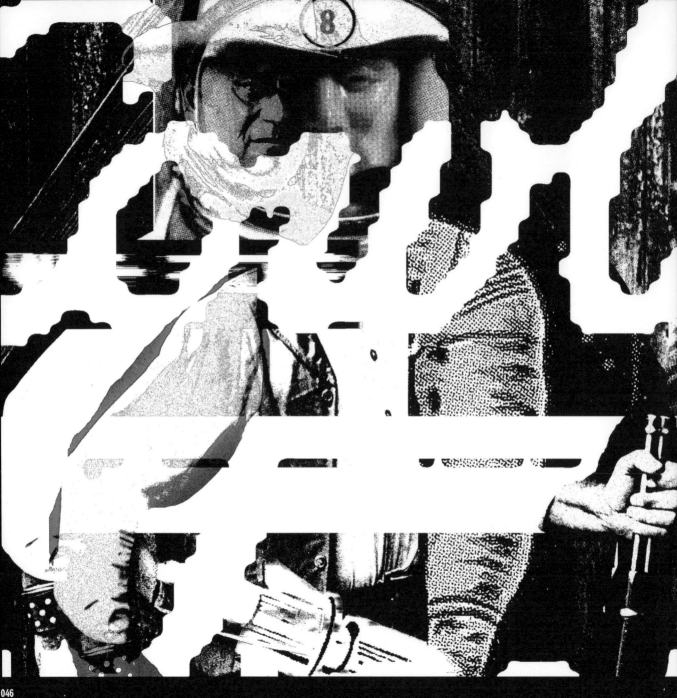

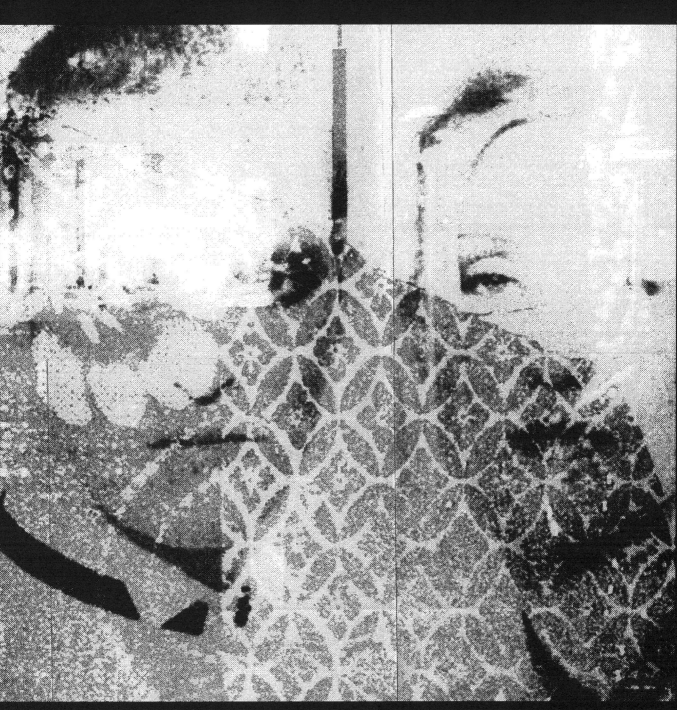

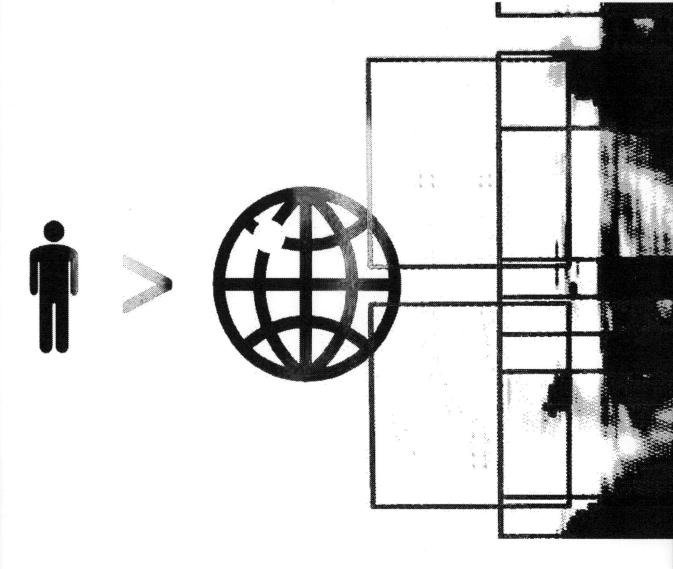

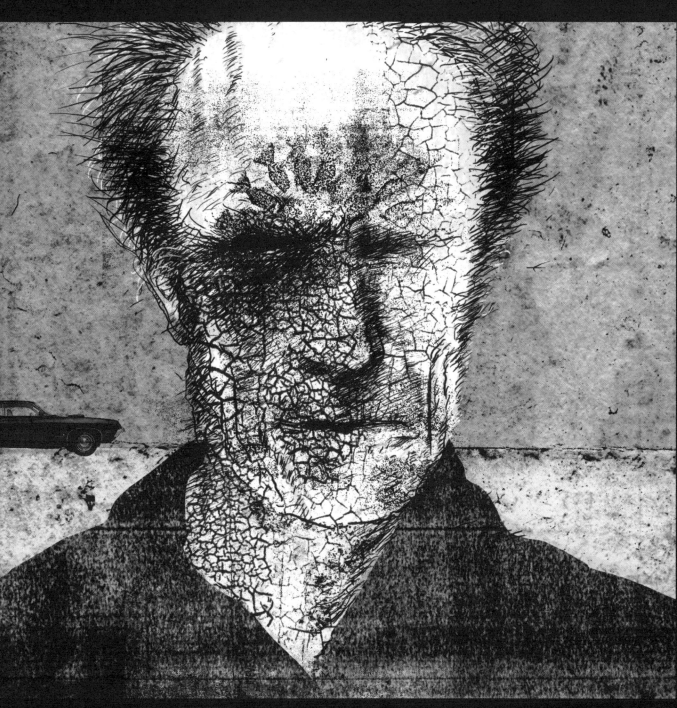

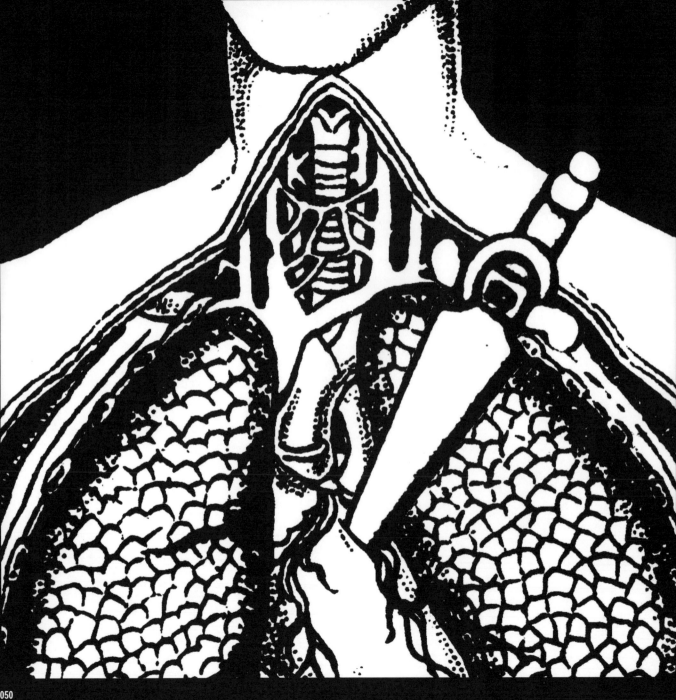

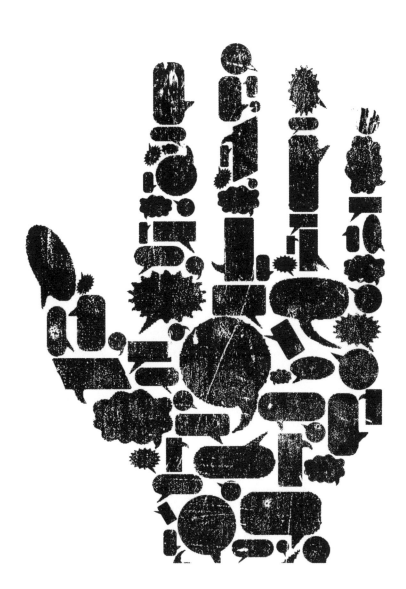

051

COTTON TALES

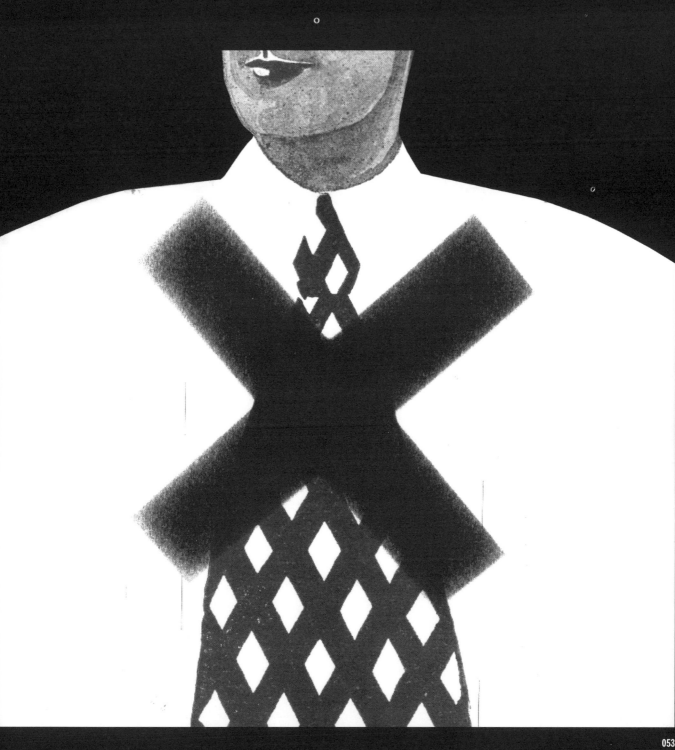

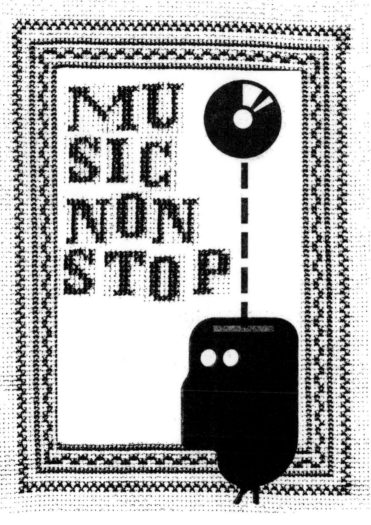

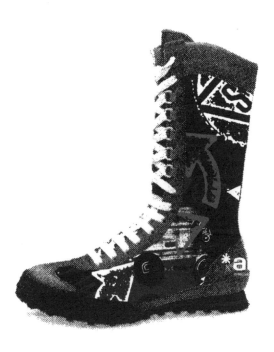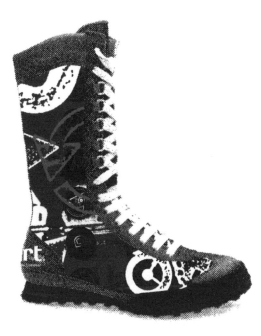

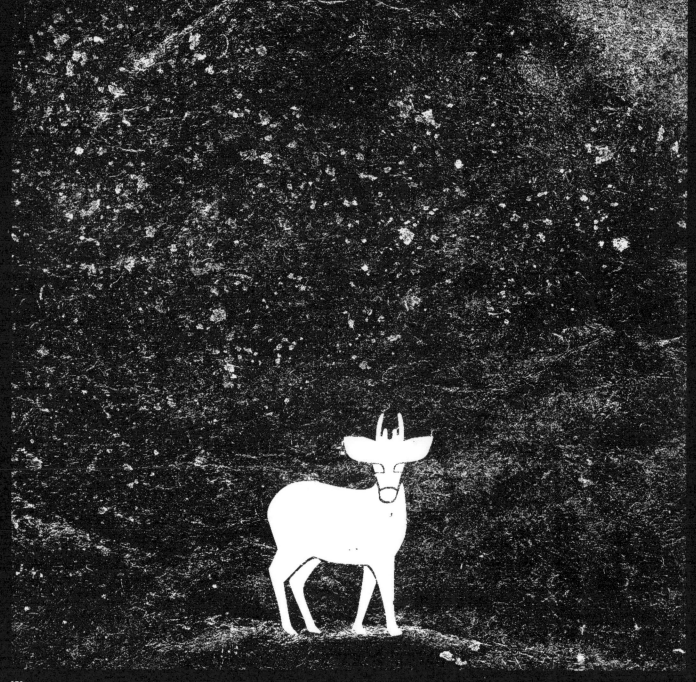

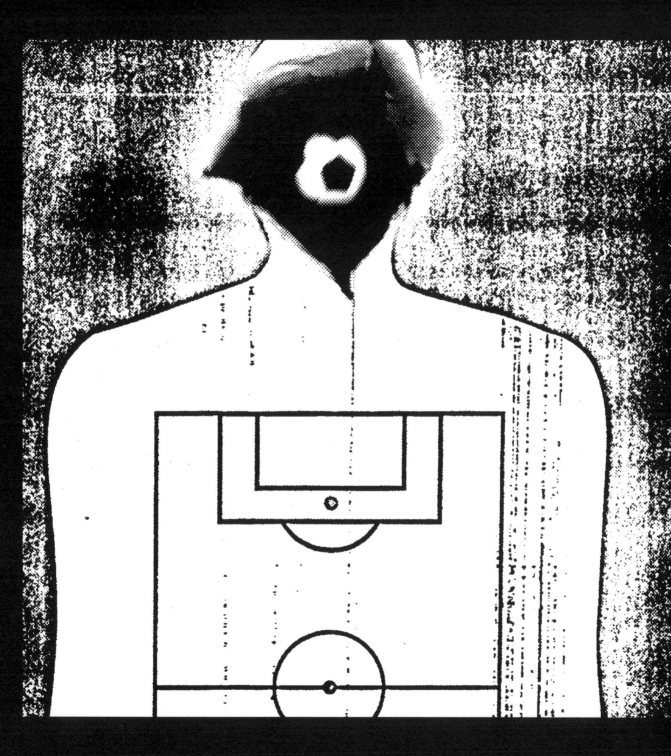

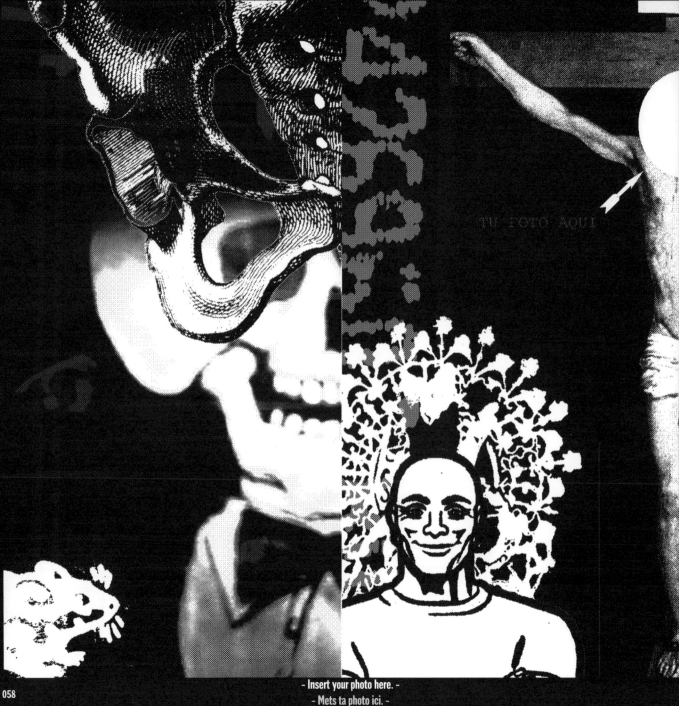

TU FOTO AQUI

- Insert your photo here. -
- Mets ta photo ici. -

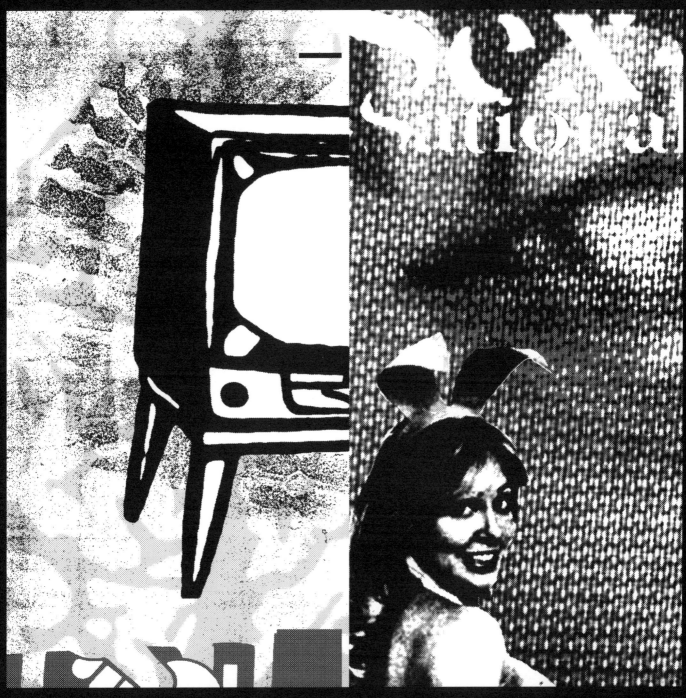

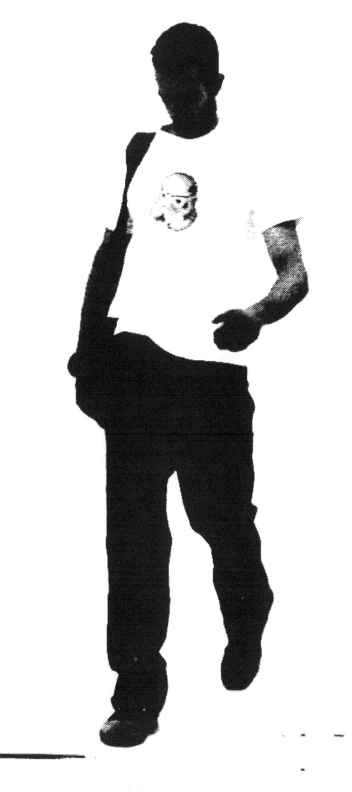

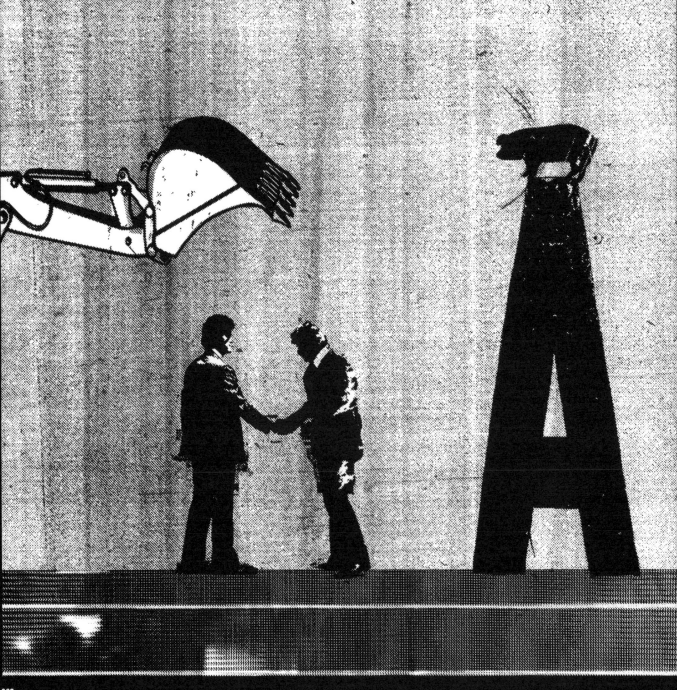

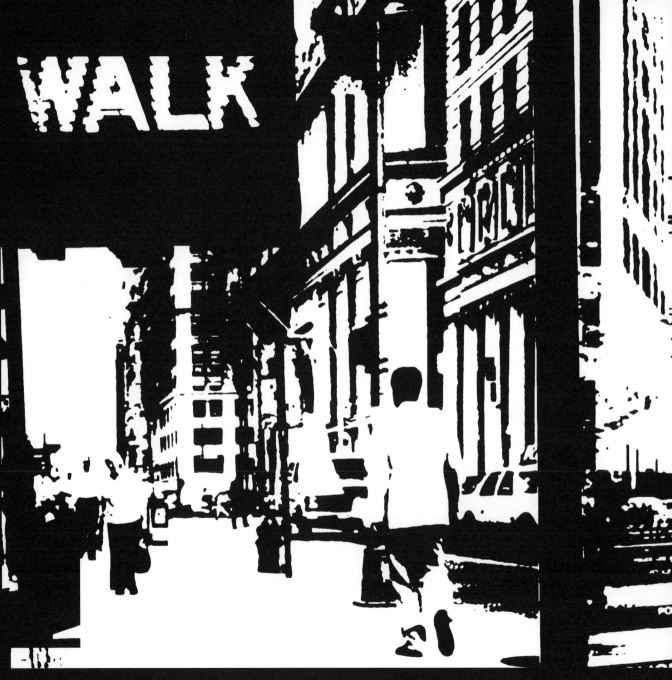

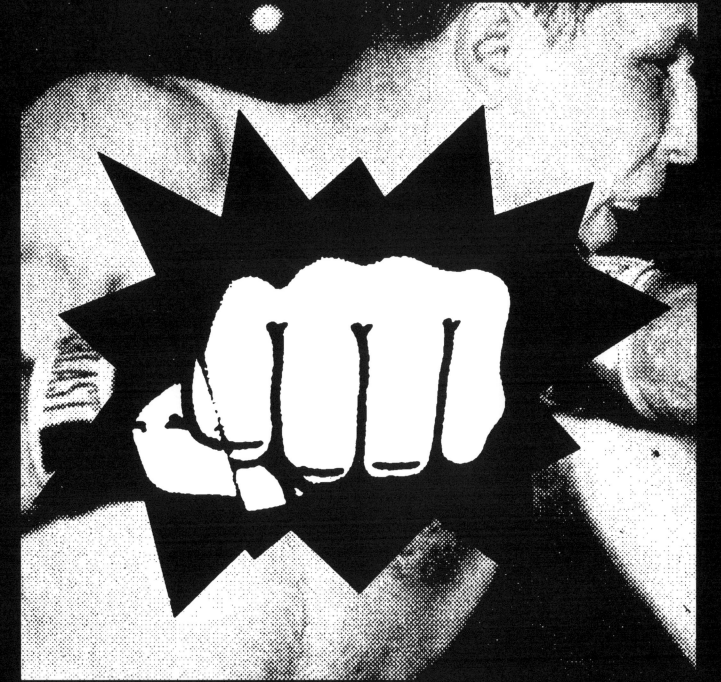

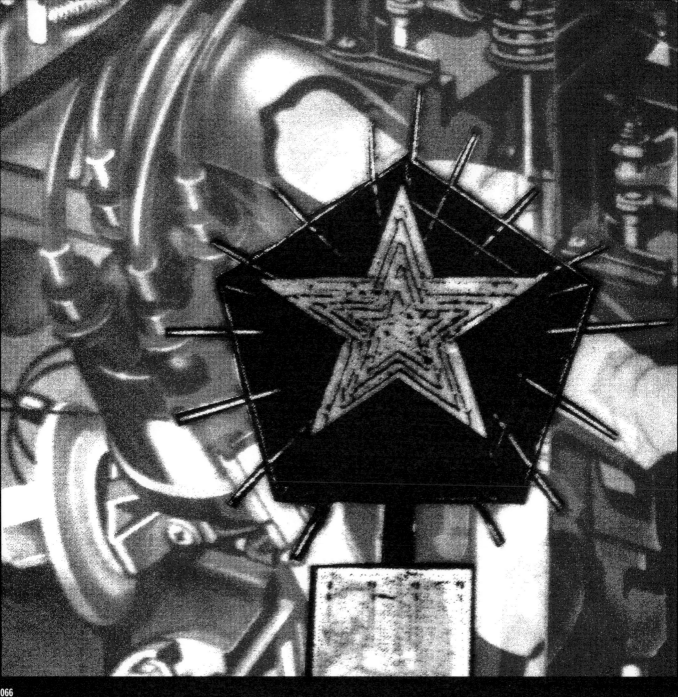

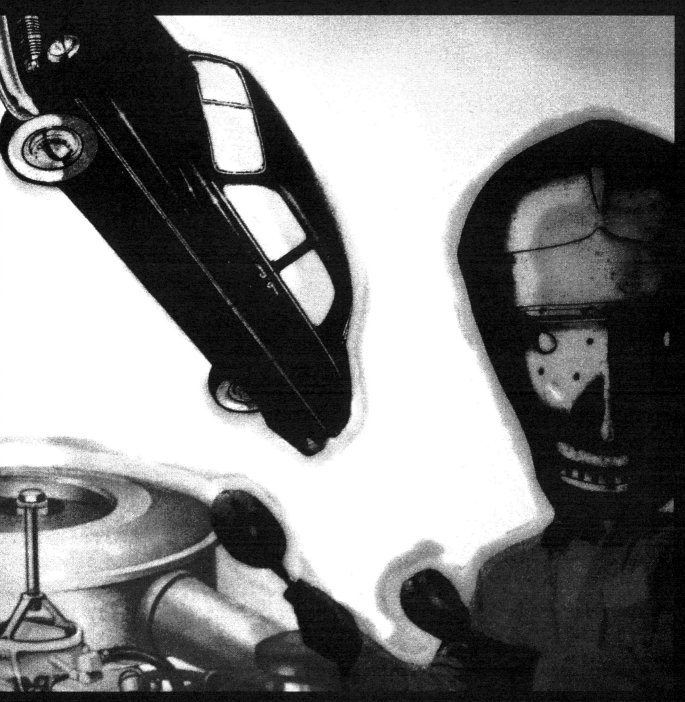

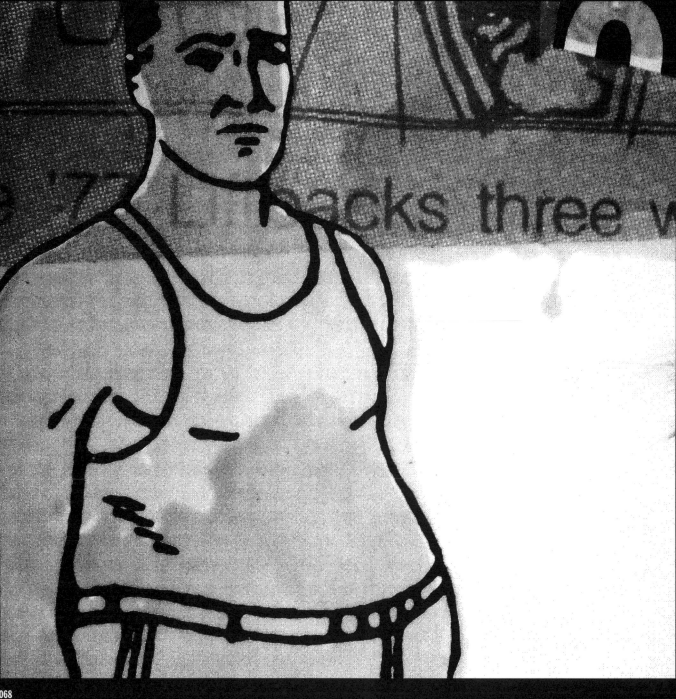

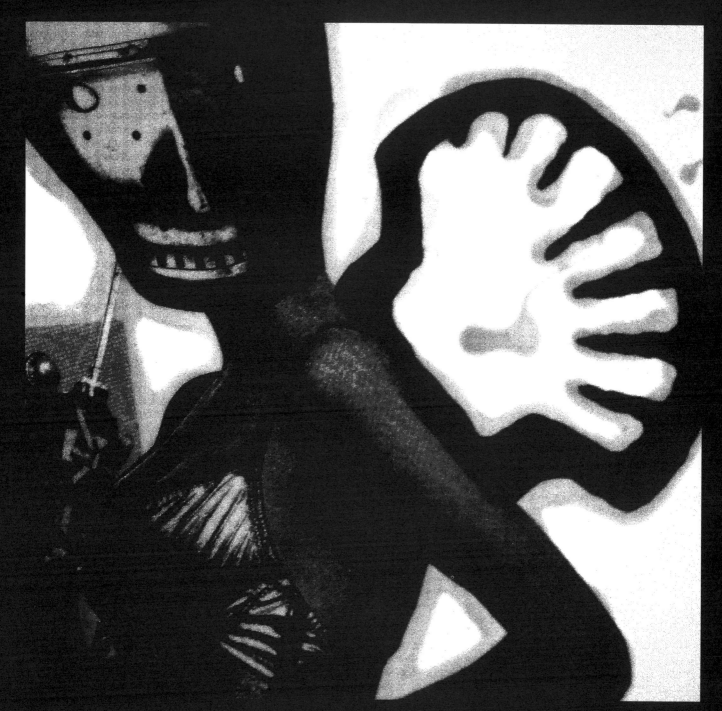

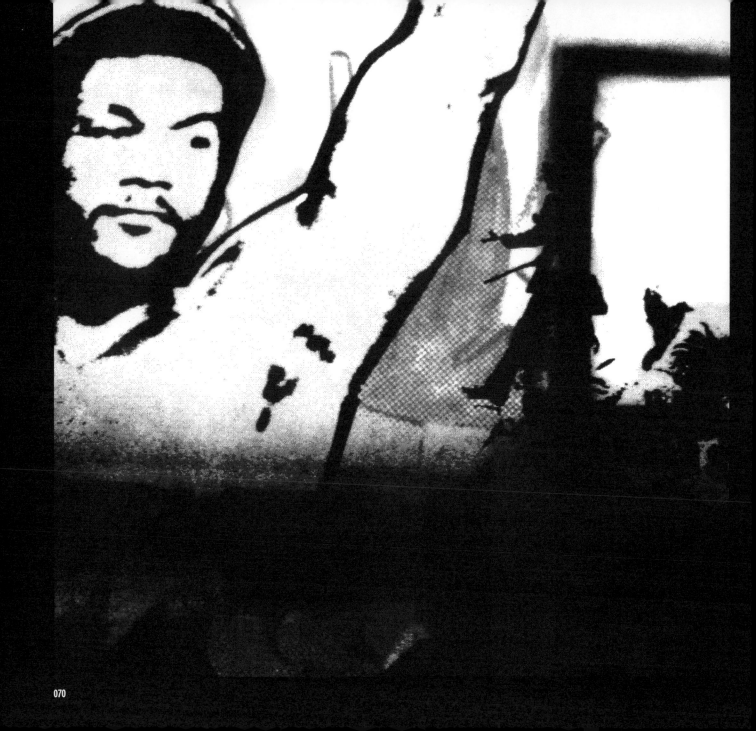

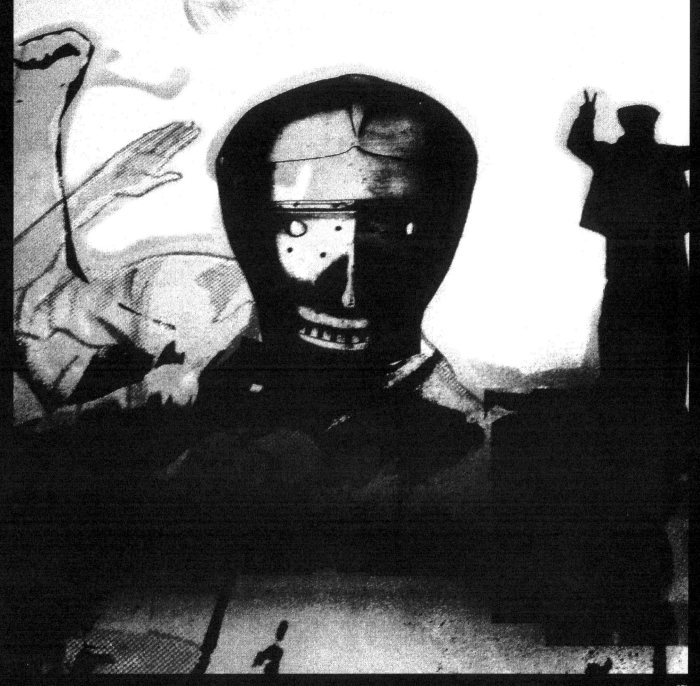

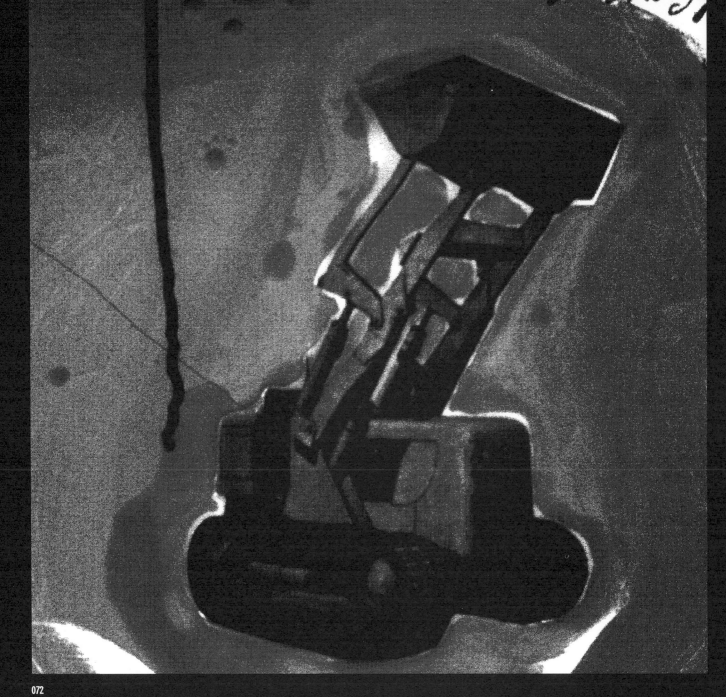

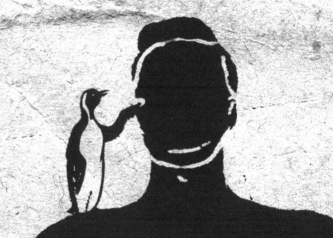

- A new man, more enterprising, more dynamic, more manly. -
- Un homme nouveau, plus entreprenant, plus dynamique, plus viril. -

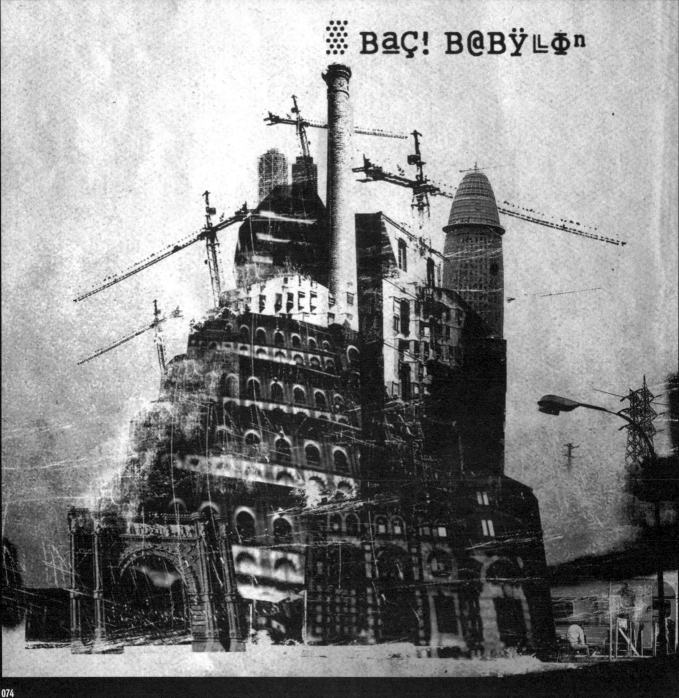

BAÇ! B@BŸLⱢǾⁿ

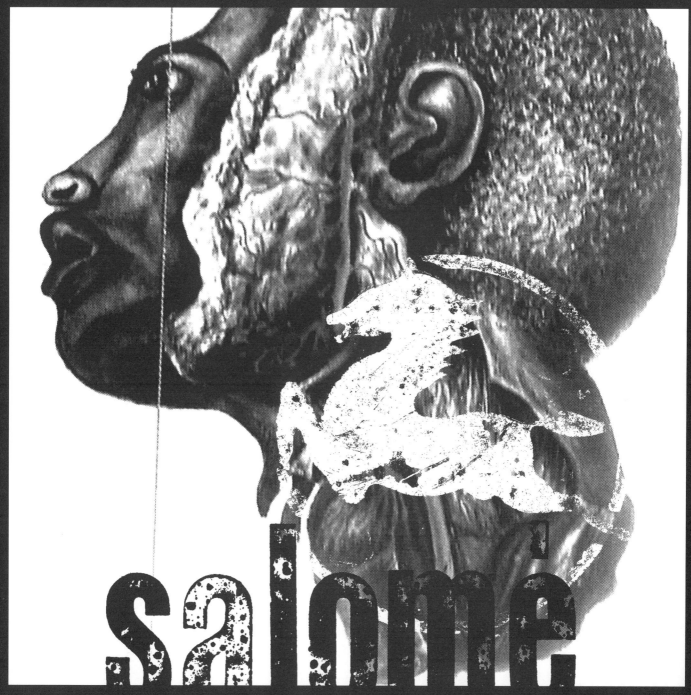

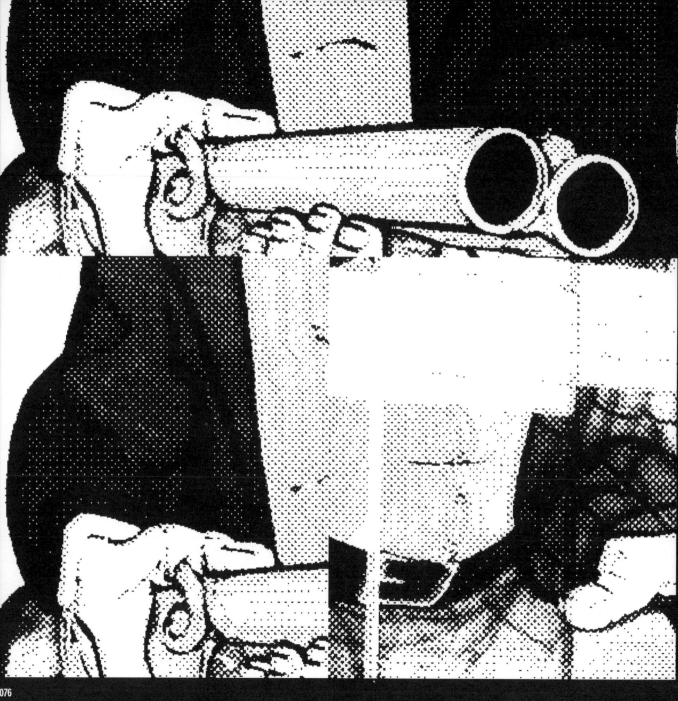

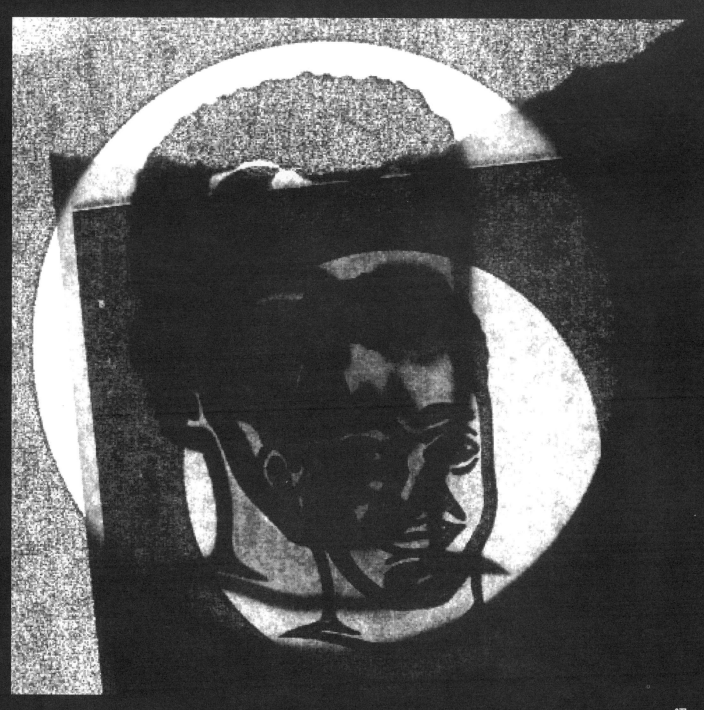

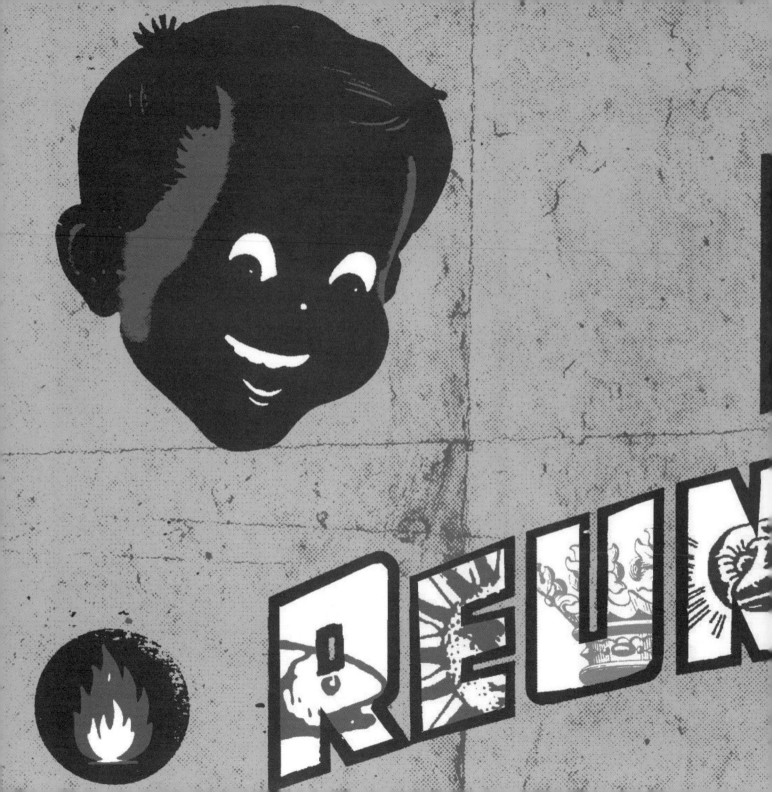

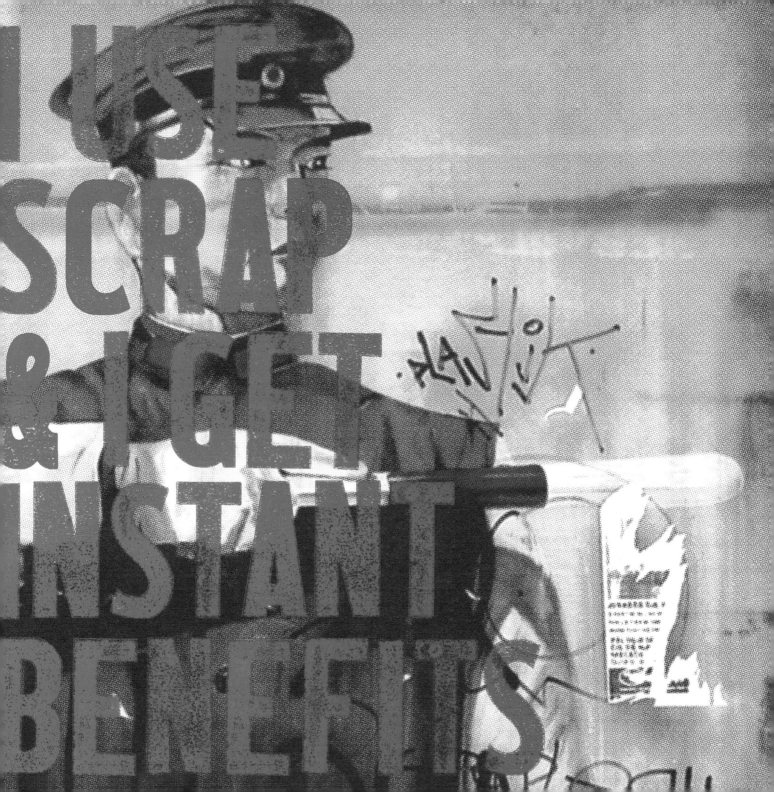

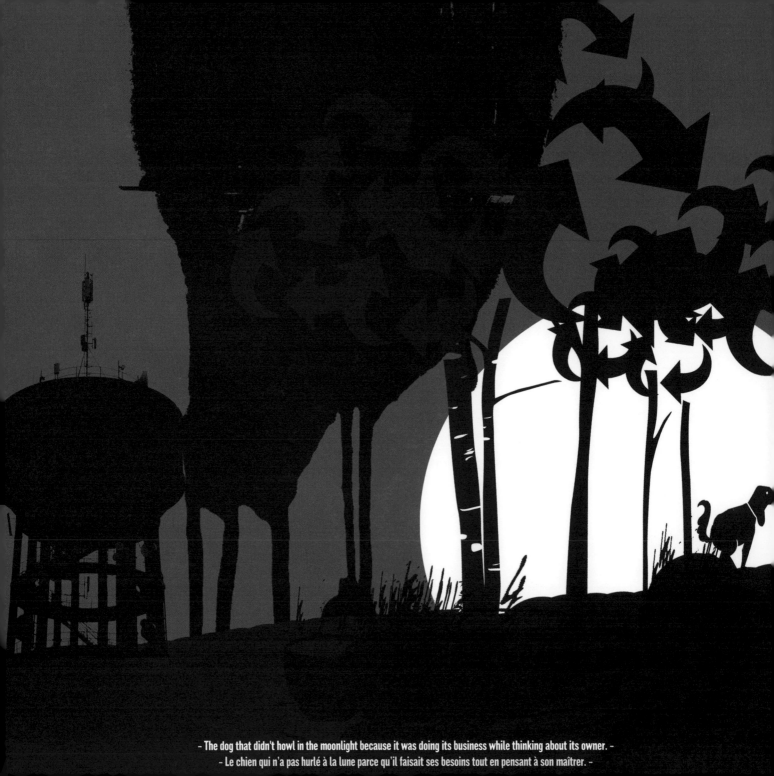

- The dog that didn't howl in the moonlight because it was doing its business while thinking about its owner. -
- Le chien qui n'a pas hurlé à la lune parce qu'il faisait ses besoins tout en pensant à son maîtrer. -

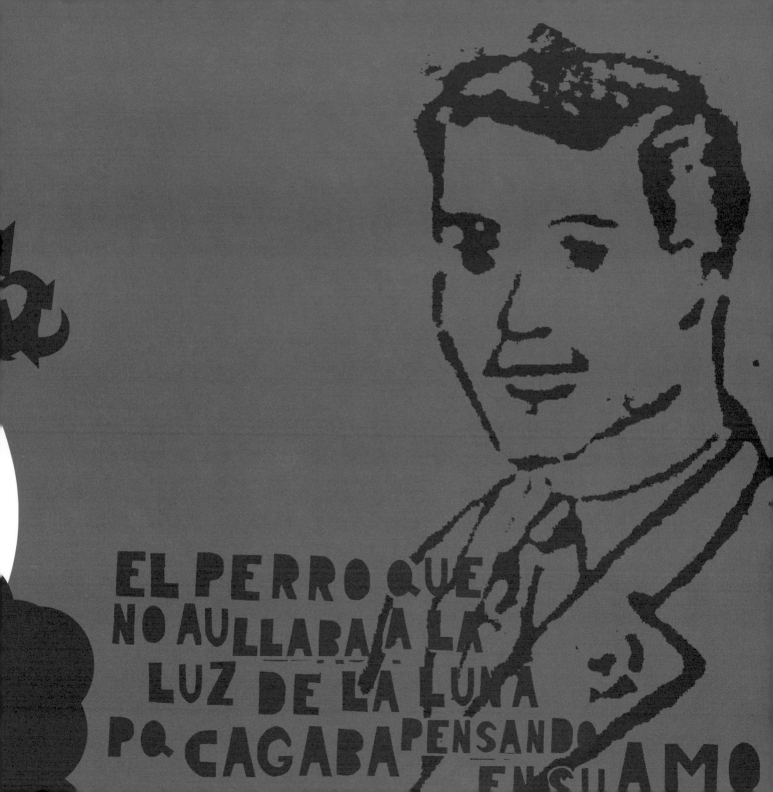

EL PERRO QUE
NO AULLABA A LA
LUZ DE LA LUNA
PQ CAGABA PENSANDO
EN SU AMO

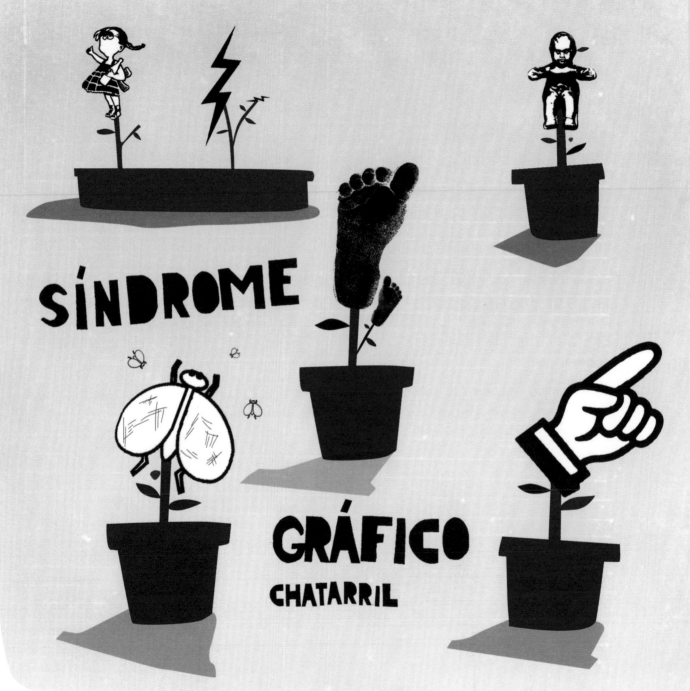

SÍNDROME

GRÁFICO
CHATARRIL

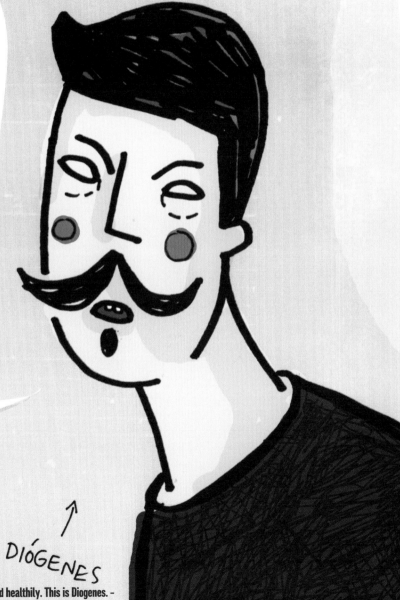

- My Scrap grows beautifully and healthily. This is Diogenes. -
- Mon graphisme revisité revit et prospère. C'est Diogène. -

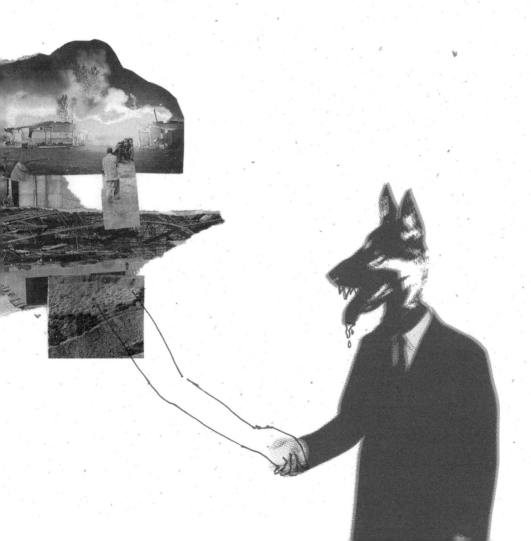

... and 〈figure〉 lived unhappily in **Berlin**.

〈figure〉 loved 〈figure〉, but he couldn't go on with that life. The many responsibilities and worries had overwhelmed him. 〈figure〉 no longer looked at 〈figure〉. 〈figure〉 eagered to be 〈figure〉. According to 〈figure〉 that was the most absolute happiness, without responsabilities, without concern. The tranquility, the blessed ignorance, the empty completeness.

〈figure〉 suffered from insomnia. Night after night, sitting in front of the tv, she would passively watch a succession of stories, the succession of cathodic lives. 〈figure〉 wanted to star in each one of them. Her life in **Berlin**, next to 〈figure〉, wasn't really a life, because life is to be alive and they just seemed to be dead. That wasn't like any of the stories that 〈figure〉 lived each night.

Every night 〈figure〉 went to a famous 〈Show Video Kabinen〉 in **Berlin**. Monday, 〈Show Video〉. Tuesday, 〈Show Video Kabinen〉. Wednesday, 〈Video〉. Thursday, 〈Video Kabinen〉. Friday, 〈Kabinen〉. Saturday, 〈Kabinen〉. Sunday, 〈Video Kabinen〉. There he met 〈figure〉, a dancer of savage beauty.

〈figure〉 knew 〈figure〉〈figure〉〈figure〉, and envied them. 〈figure〉〈figure〉〈figure〉 were happy. Social relationships, work, clothes, love... they lived in a world tailored for them. 〈figure〉 didn't want to be a simple extra, a sad photo, a submissive company. 〈figure〉 wanted to be 〈figure〉. That's why she began to work in the 〈Show Video Kabinen〉 in **Berlin**

in the first place. It was an unique show. was fantastic; Wild, but oddly human. lived in the *Show Video Kabinen*, in the room with the ❁.

and , each night after the show, had sex for hours in the room with the ❁. That was the place they had chosen to deliver themselves to pleasure night after night. But it wasn't a selfless pleasure. wanted to be and wanted to be . It was that metamorphosis that moved them. They thought that by giving their bodies to one another they would accomplish the desired goal. But they just brought more sadness and rejection to themselves. Deluded.

 would always see as an and would always see as a .

What and weren't aware of is that the life of in 𝕭𝖊𝖗𝖑𝖎𝖓 was much more human than that of most , and that the life of was more than that of most .

That was simultaneously their desire and their damnation. And it would be so until the end of their lives.

Meanwhile, kept living lives without really living them, oblivious to what happened outside, in 𝕭𝖊𝖗𝖑𝖎𝖓, in the *Show Video Kabinen* or in the room with the ❁.

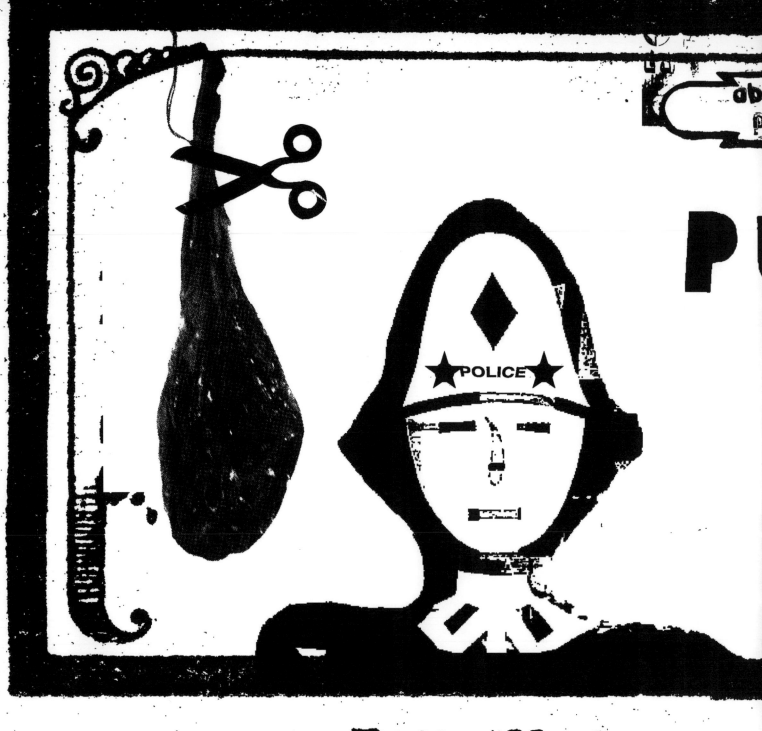

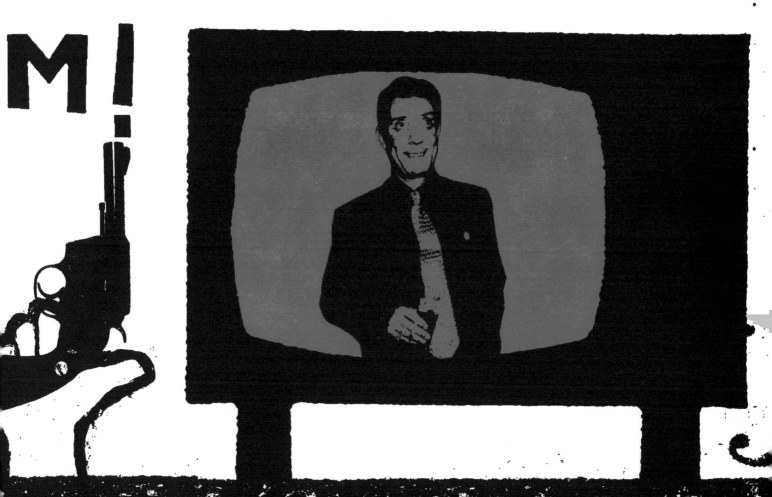

NAIF LOVERS

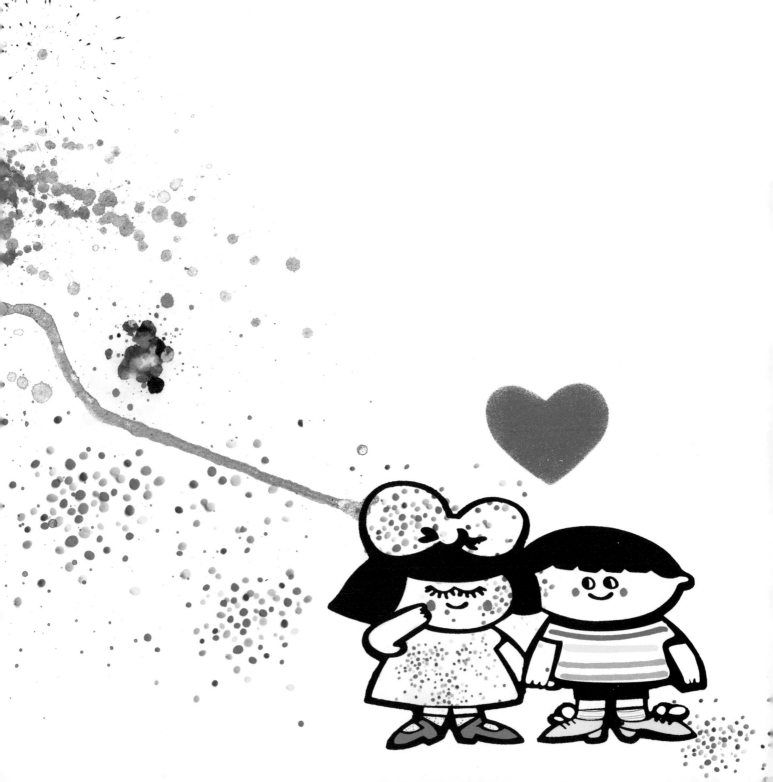

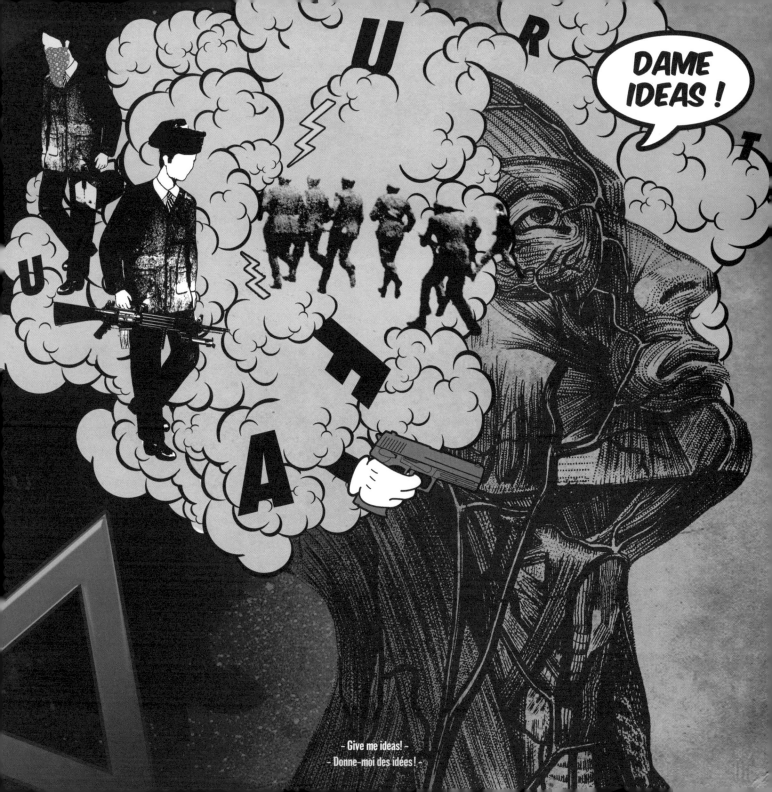

- Give me ideas! -
- Donne-moi des idées! -

 www.wantedestudio.com

 www.juditreig.net

 www.juliasolans.com

 mrokins.blogspot.com

 www.sarasilvasantos.net

 www.danimelo.biz

 www.carlesmurillo.com

CÓMO COGER
PALILLOS

ndo palillo
no usted

ón

jo.

sa

PART
THREE

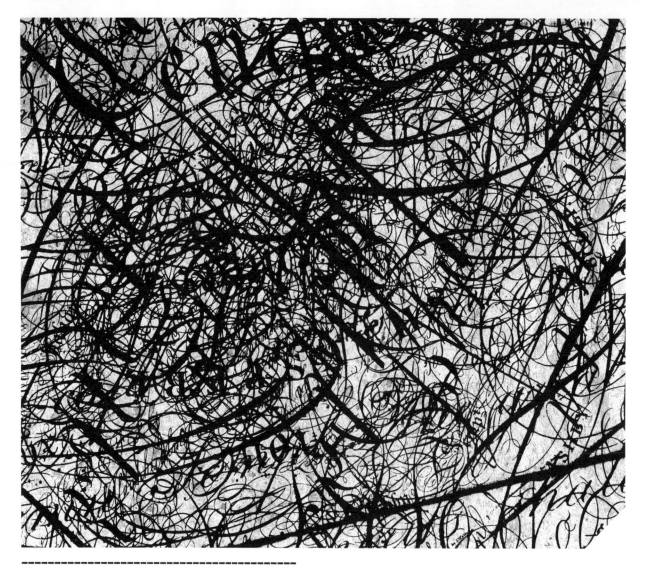

XG. ———————————————————————————— REF: 001

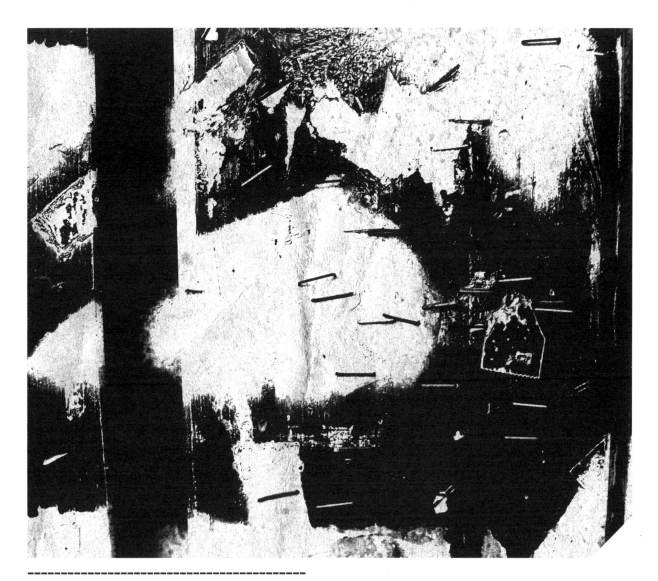

XG. REF: 002

These images can be found on the CD-ROM included at the back of the book. Ces images se trouvent sur le CD-ROM inclus dans la pochette intérieure de l'ouvrage. Estas imágenes las puedes encontrar en el CD-ROM adjunto al final del libro.

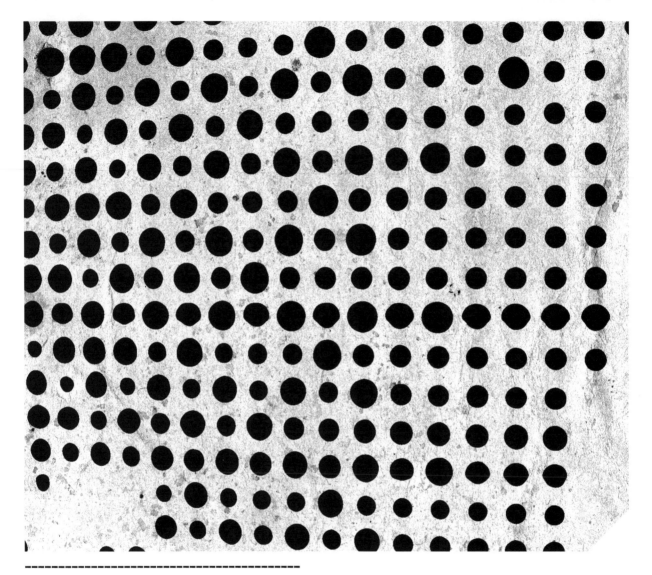

XG. REF: 003

These images can be found on the CD-ROM included at the back of the book. Ces images se trouvent sur le CD-ROM inclus dans la pochette intérieure de l'ouvrage. Estas imágenes las puedes encontrar en el CD-ROM adjunto al final del libro.

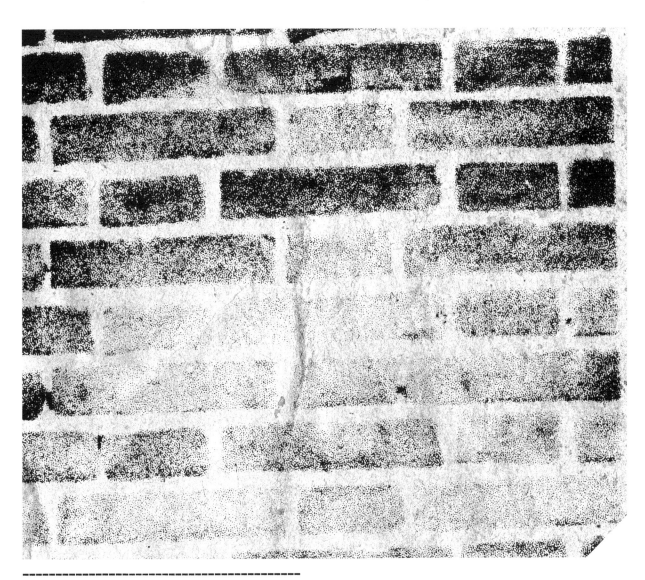

XG. REF: 004

These images can be found on the CD-ROM included at the back of the book. Ces images se trouvent sur le CD-ROM inclus dans la pochette intérieure de l'ouvrage. Estas imágenes las puedes encontrar en el CD-ROM adjunte al final del libro.

XG. REF: 005

XG. REF: 006

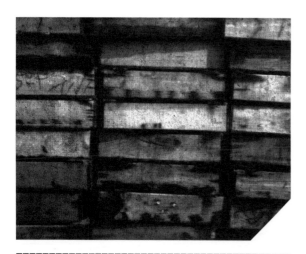

XG. REF: 007

XG. REF: 008

These images can be found on the CD-ROM included at the back of the book. Ces images se trouvent sur le CD-ROM inclus dans la pochette intérieure de l'ouvrage. Estas imágenes las puedes encontrar en el CD-ROM adjunto al final del libro.

XG. REF: 009

XG. REF: 010

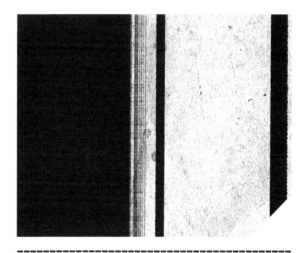

XG. REF: 011

XG. REF: 012

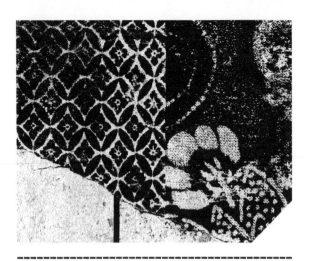

XG. REF: 013

XG. REF: 014

XG. REF: 015

XG. REF: 016

These images can be found on the CD-ROM included at the back of the book. Ces images se trouvent sur le CD-ROM inclus dans la pochette intérieure de l'ouvrage. Estas imágenes las puedes encontrar en el CD-ROM adjunto al final del libro.

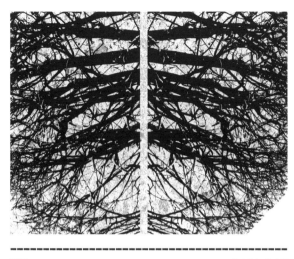

XG. REF: 017

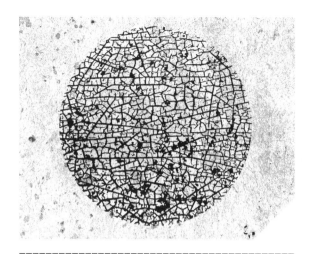

XG. REF: 018

XG. REF: 019

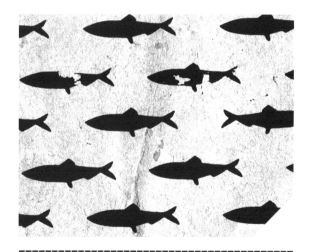

XG. REF: 020

These images can be found on the CD-ROM included at the back of the book. Ces images se trouvent sur le CD-ROM inclus dans la pochette intérieure de l'ouvrage. Estas imágenes las puedes encontrar en el CD-ROM adjunte al final del libro.

XG. REF: 021

XG. REF: 022

XG. REF: 023

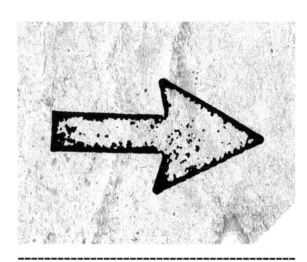

XG. REF: 024

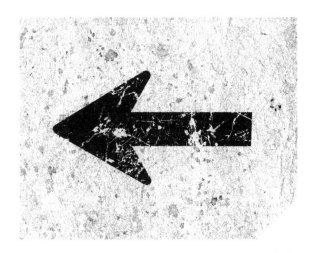

XG. REF: 025

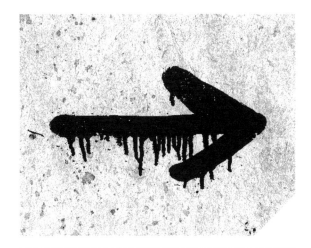

XG. REF: 026

XG. REF: 027

XG. REF: 028

These images can be found on the CD-ROM included at the back of the book. Ces images se trouvent sur le CD-ROM inclus dans la pochette intérieure de l'ouvrage. Estas imágenes las puedes encontrar en el CD-ROM adjunte al final del libro.

XG. REF: 029

XG. REF: 030

XG. REF: 031

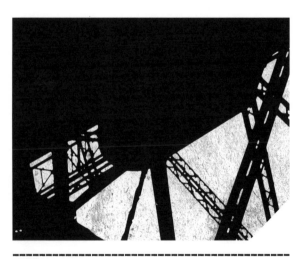

XG. REF: 032

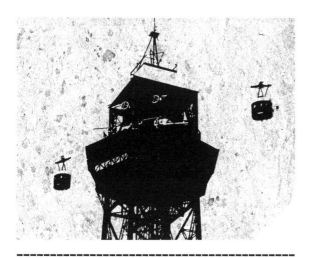

XG. REF: 033

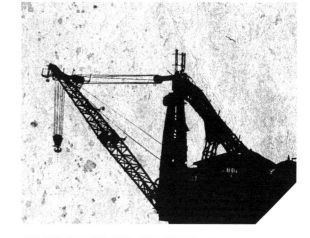

XG. REF: 034

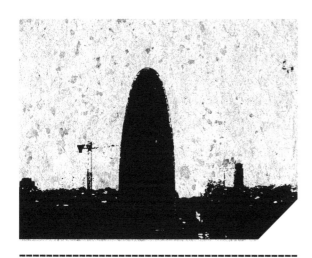

XG. REF: 035

XG. REF: 036

These images can be found on the CD-ROM included at the back of the book. Ces images se trouvent sur le CD-ROM inclus dans la pochette intérieure de l'ouvrage. Estas imágenes las puedes encontrar en el CD-ROM adjunto al final del libro.

XG. REF: 037

XG. REF: 038

XG. REF: 039

XG. REF: 040

These images can be found on the CD-ROM included at the back of the book. Ces images se trouvent sur le CD-ROM inclus dans la pochette intérieure de l'ouvrage. Estas imágenes las puedes encontrar en el CD-ROM adjunto al final del libro.

XG. REF: 041

XG. REF: 042

XG. REF: 043

XG. REF: 044

These images can be found on the CD-ROM included at the back of the book. Ces images se trouvent sur le CD-ROM inclus dans la pochette intérieure de l'ouvrage. Estas imágenes las puedes encontrar en el CD-ROM adjunto al final del libro.

XG. REF: 045

XG. REF: 046

XG. REF: 047

XG. REF: 048

XG. REF: 049

XG. REF: 050

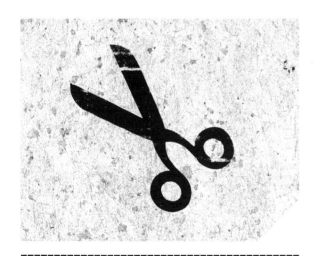

XG. REF: 051

XG. REF: 052

These images can be found on the CD-ROM included at the back of the book. Ces images se trouvent sur le CD-ROM inclus dans la pochette intérieure de l'ouvrage. Estas imágenes las puedes encontrar en el CD-ROM adjunto al final del libro.

XG. REF: 053

These images can be found on the CD-ROM included at the back of the book. Ces images se trouvent sur le CD-ROM inclus dans la pochette intérieure de l'ouvrage. Estas imágenes las puedes encontrar en el CD-ROM adjunto al final del libro.

XG. **REF: 054**

These images can be found on the CD-ROM included at the back of the book. Ces images se trouvent sur le CD-ROM inclus dans la pochette intérieure de l'ouvrage. Estas imágenes las puedes encontrar en el CD-ROM adjunto al final del libro.

XG. REF: 055

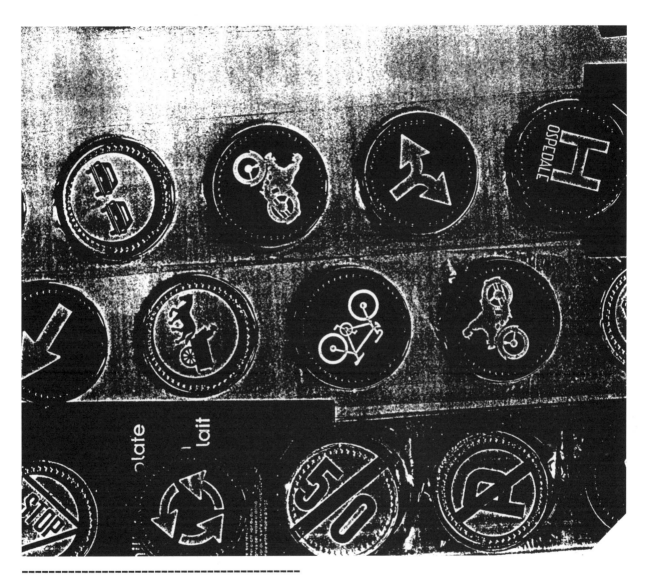

XG. REF: 056

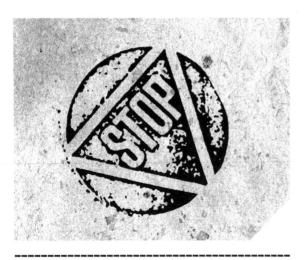

XG. **REF: 057**

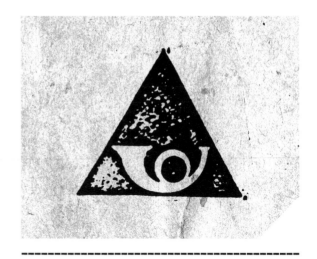

XG. **REF: 058**

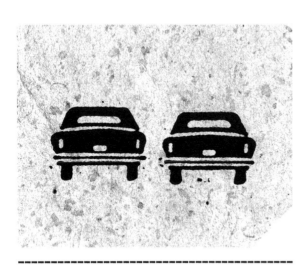

XG. **REF: 059**

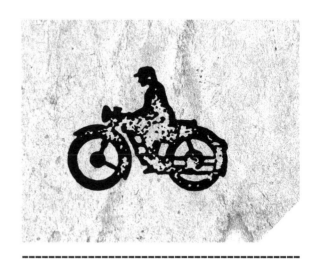

XG. **REF: 060**

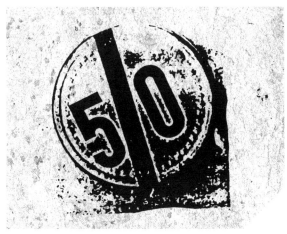

XG. REF: 061

XG. REF: 062

XG. REF: 063

XG. REF: 064

XG. REF: 065

XG. REF: 066

XG. REF: 067

XG. REF: 068

These images can be found on the CD-ROM included at the back of the book. Ces images se trouvent sur le CD-ROM inclus dans la pochette intérieure de l'ouvrage. Estas imágenes las puedes encontrar en el CD-ROM adjunto al final del libro.

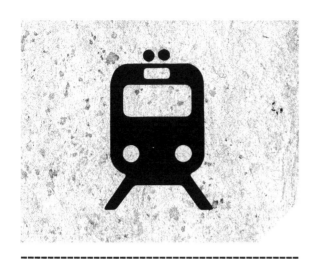

XG. REF: 069

XG. REF: 070

XG. REF: 071

XG. REF: 072

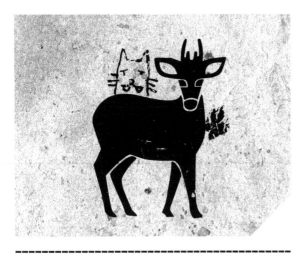

XG. REF: 073

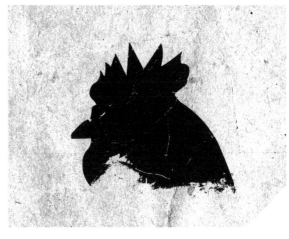

XG. REF: 074

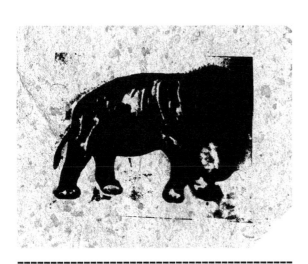

XG. REF: 075

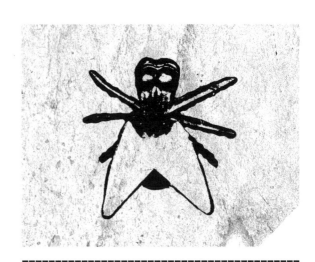

XG. REF: 076

XG. REF: 077

XG. REF: 078

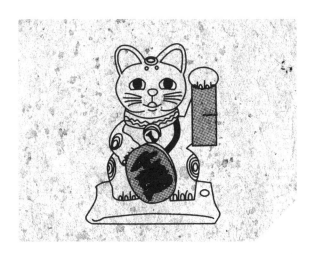

XG. REF: 079

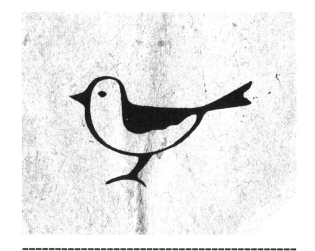

XG. REF: 080

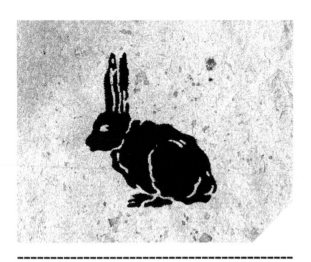

XG. REF: 081

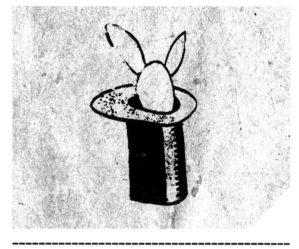

XG. REF: 082

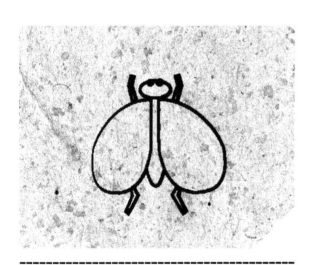

XG. REF: 083

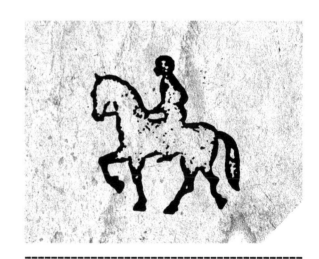

XG. REF: 084

These images can be found on the CD-ROM included at the back of the book. Ces images se trouvent sur le CD-ROM inclus dans la pochette intérieure de l'ouvrage. Estas imágenes las puedes encontrar en el CD-ROM adjunto al final del libro.

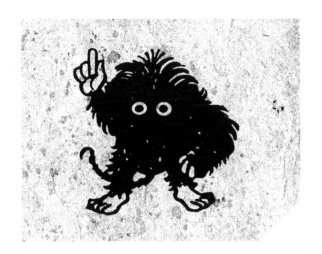

--
XG. REF: 085
--

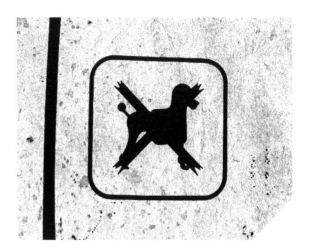

--
XG. REF: 086
--

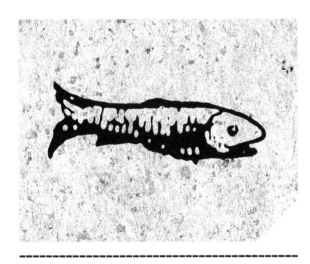

--
XG. REF: 087
--

--
XG. REF: 088
--

XG. REF: 089

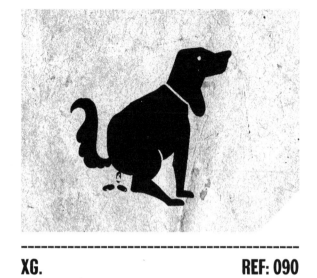

XG. REF: 090

XG. REF: 091

XG. REF: 092

These images can be found on the CD-ROM included at the back of the book. Ces images se trouvent sur le CD-ROM inclus dans la pochette intérieure de l'ouvrage. Estas imágenes las puedes encontrar en el CD-ROM adjunto al final del libro.

XG. REF: 093

XG. REF: 094

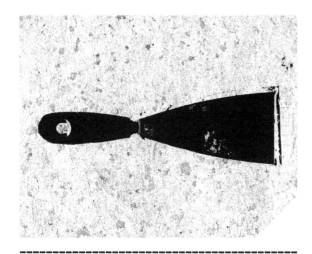

XG. REF: 095

XG. REF: 096

These images can be found on the CD-ROM included at the back of the book. Ces images se trouvent sur le CD-ROM inclus dans la pochette intérieure de l'ouvrage. Estas imágenes las puedes encontrar en el CD-ROM adjunto al final del libro.

XG. REF: 097

XG. REF: 098

XG. REF: 099

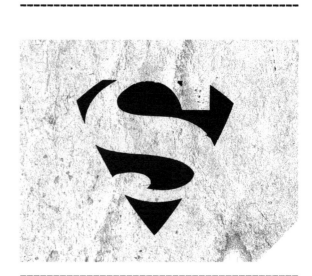

XG. REF: 100

These images can be found on the CD-ROM included at the back of the book. Ces images se trouvent sur le CD-ROM inclus dans la pochette intérieure de l'ouvrage. Estas imágenes las puedes encontrar en el CD-ROM adjunto al final del libro.

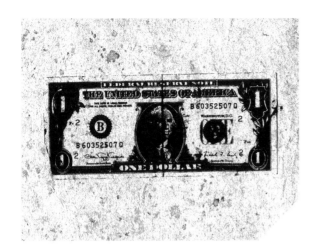

XG. **REF: 101**

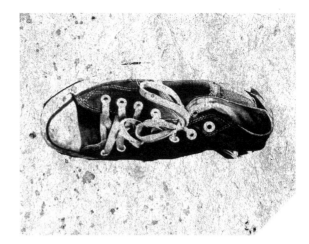

XG. **REF: 102**

XG. **REF: 103**

XG. **REF: 104**

These images can be found on the CD-ROM included at the back of the book. Ces images se trouvent sur le CD-ROM inclus dans la pochette intérieure de l'ouvrage. Estas imágenes las puedes encontrar en el CD-ROM adjunto al final del libro.

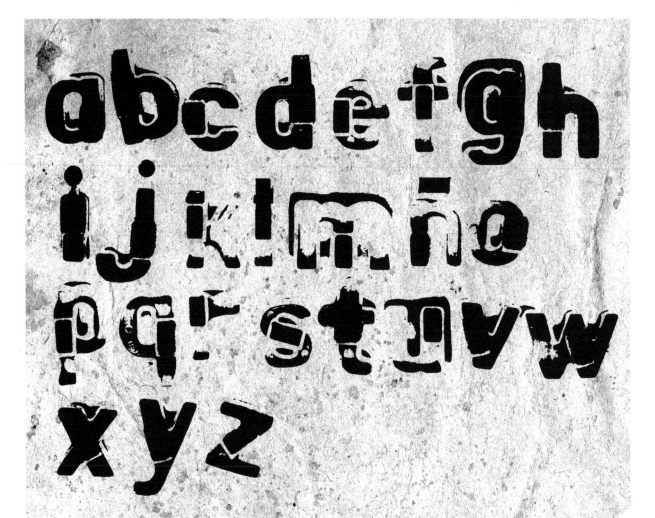

XG. REF: 105

XG. REF: 106

These images can be found on the CD-ROM included at the back of the book. Ces images se trouvent sur le CD-ROM inclus dans la pochette intérieure de l'ouvrage. Estas imágenes las puedes encontrar en el CD-ROM adjunto al final del libro.

ABCDEF
GHIJKM
NÑLLLLOP
QRSTUV
WXYZ

XG. _____ REF: 107

These images can be found on the CD-ROM included at the back of the book. Ces images se trouvent sur le CD-ROM inclus dans la pochette intérieure de l'ouvrage. Estas imágenes las puedes encontrar en el CD-ROM adjunto al final del libro.

ABCDEFGHIJ
KMNÑLLLOPQ
RSTUVWXYZ

--
XG. REF: 108
--

These images can be found on the CD-ROM included at the back of the book. Ces images se trouvent sur le CD-ROM inclus dans la pochette intérieure de l'ouvrage. Estas imágenes las puedes encontrar en el CD-ROM adjunto al final del libro.

XG. **REF: 109**

AVENTURA

XG. **REF: 110**

XG. **REF: 111**

XG. **REF: 112**

XG. REF: 113

XG. REF: 114

XG. REF: 115

XG. REF: 116

These images can be found on the CD-ROM included at the back of the book. Ces images se trouvent sur le CD-ROM inclus dans la pochette intérieure de l'ouvrage. Estas imágenes las puedes encontrar en el CD-ROM adjunto al final del libro.

XG. REF: 117

Berlin

XG. REF: 118

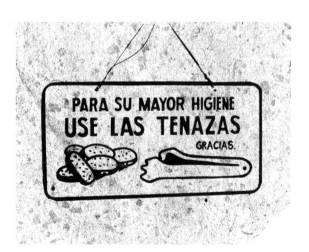

XG. REF: 119

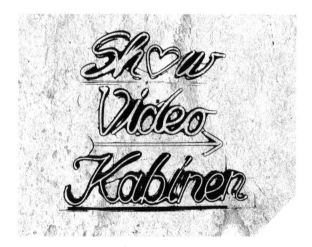

XG. REF: 120

XG. REF: 121

XG. REF: 122

XG. 123

XG. REF: 124

These images can be found on the CD-ROM included at the back of the book. Ces images se trouvent sur le CD-ROM inclus dans la pochette intérieure de l'ouvrage. Estas imágenes las puedes encontrar en el CD-ROM adjunto al final del libro.

XG. REF: 125

XG. REF: 126

XG. REF: 127

XG. REF: 128

These images can be found on the CD-ROM included at the back of the book. Ces images se trouvent sur le CD-ROM inclus dans la pochette intérieure de l'ouvrage. Estas imágenes las puedes encontrar en el CD-ROM adjunto al final del libro.

XG. REF: 129

XG. REF: 130

XG. REF: 131

XG. REF: 132

These images can be found on the CD-ROM included at the back of the book. Ces images se trouvent sur le CD-ROM inclus dans la pochette intérieure de l'ouvrage. Estas imágenes las puedes encontrar en el CD-ROM adjunto al final del libro.

XG. REF: 133

XG. REF: 134

XG. REF: 135

XG. REF: 136

XG. REF: 137

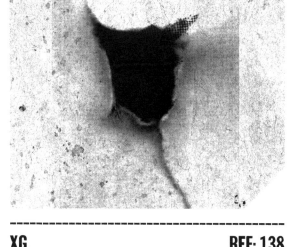

XG. REF: 138

XG. REF: 139

XG. REF: 140

XG. REF: 141

XG. REF: 142

XG. REF: 143

XG. REF: 144

XG. REF: 145

XG. REF: 146

XG. REF: 147

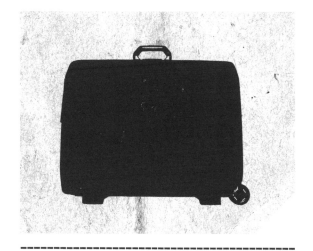

XG. REF: 148

These images can be found on the CD-ROM included at the back of the book. Ces images se trouvent sur le CD-ROM inclus dans la pochette intérieure de l'ouvrage. Estas imágenes las puedes encontrar en el CD-ROM adjunto al final del libro.

XG. REF: 149

XG. REF: 150

XG. REF: 151

XG. REF: 152

These images can be found on the CD-ROM included at the back of the book. Ces images se trouvent sur le CD-ROM inclus dans la pochette intérieure de l'ouvrage. Estas imágenes las puedes encontrar en el CD-ROM adjunto al final del libro.

XG. **REF: 153**

XG. **REF: 154**

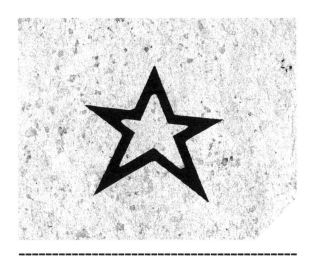

XG. **REF: 155**

XG. **REF: 156**

These images can be found on the CD-ROM included at the back of the book. Ces images se trouvent sur le CD-ROM inclus dans la pochette intérieure de l'ouvrage. Estas imágenes las puedes encontrar en el CD-ROM adjunto al final del libro.

XG. REF: 157

XG. —————————————— **REF: 158**

XG. REF: 159

XG. REF: 160

XG. REF: 161

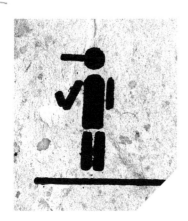

XG. REF: 162

XG. REF: 163

XG. REF: 164

XG. REF: 165

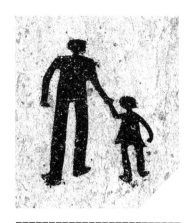

XG. REF: 166

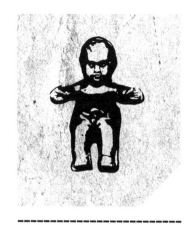

XG. REF: 167

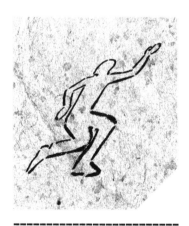

XG. REF: 168

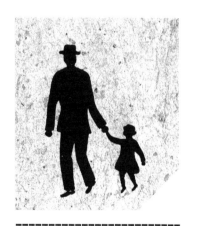

XG. REF: 169

XG. REF: 170

XG. REF: 171

XG. REF: 172

XG. REF: 173

XG. REF: 174

These images can be found on the CD-ROM included at the back of the book. Ces images se trouvent sur le CD-ROM inclus dans la pochette intérieure de l'ouvrage. Estas imágenes las puedes encontrar en el CD-ROM adjunto al final del libro.

XG. REF: 175

XG. REF: 176

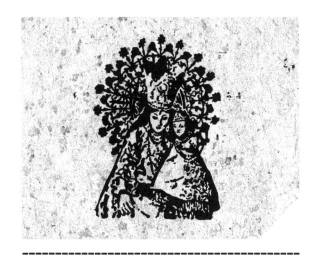

XG. REF: 177

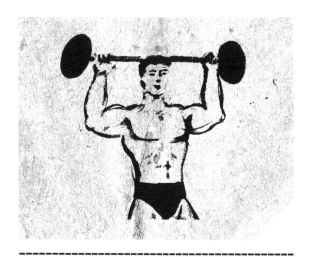

XG. REF: 178

These images can be found on the CD-ROM included at the back of the book. Ces images se trouvent sur le CD-ROM inclus dans la pochette intérieure de l'ouvrage. Estas imágenes las puedes encontrar en el CD-ROM adjunto al final del libro.

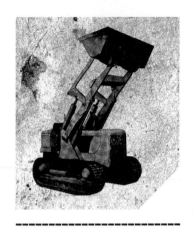

XG. REF: 179

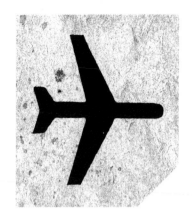

XG. REF: 180

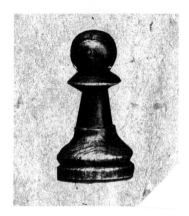

XG. REF: 181

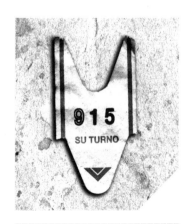

XG. REF: 182

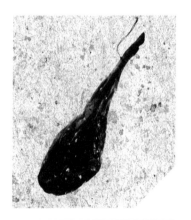

XG. REF: 183

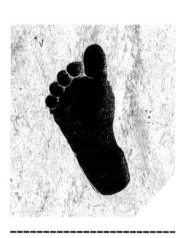

XG. REF: 184

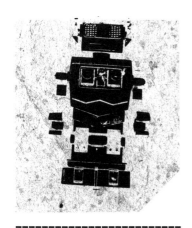

XG. REF: 185

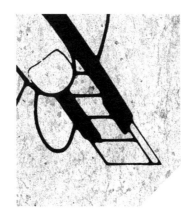

XG. REF: 186

XG. REF: 187

XG. REF: 188

XG. REF: 189

XG. REF: 190

These images can be found on the CD-ROM included at the back of the book. Ces images se trouvent sur le CD-ROM inclus dans la pochette intérieure de l'ouvrage. Estas imágenes las puedes encontrar en el CD-ROM adjunto al final del libro.

XG. REF: 191

XG. REF: 192

XG. REF: 193

XG. REF: 194

XG. REF: 195

XG. REF: 196

XG. REF: 197

XG. REF: 198

XG. REF: 199

XG. REF: 200

XG. REF: 201

XG. REF: 202

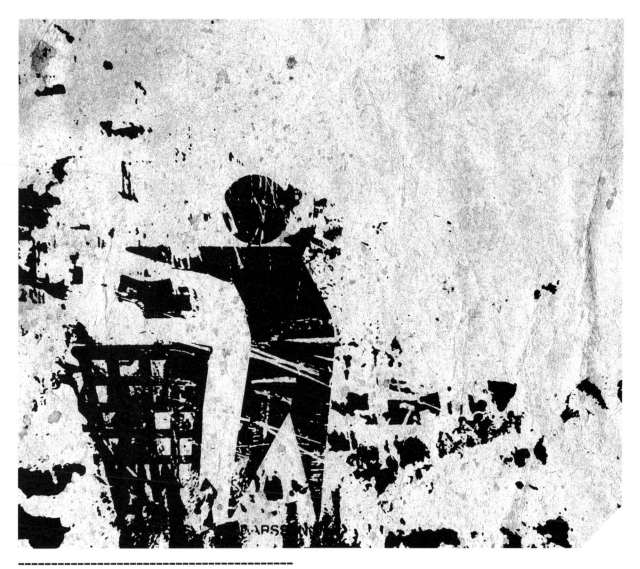

XG. REF: 203

These images can be found on the CD-ROM included at the back of the book. Ces images se trouvent sur le CD-ROM inclus dans la pochette intérieure de l'ouvrage. Estas imágenes las puedes encontrar en el CD-ROM adjunto al final del libro.

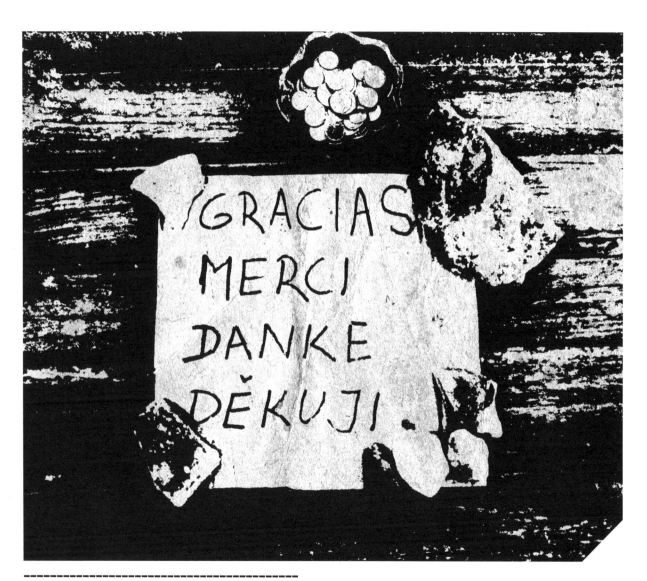

XG. REF: 204

These images can be found on the CD-ROM included at the back of the book. Ces images se trouvent sur le CD-ROM inclus dans la pochette intérieure de l'ouvrage. Estas imágenes las puedes encontrar en el CD-ROM adjunto al final del libro.

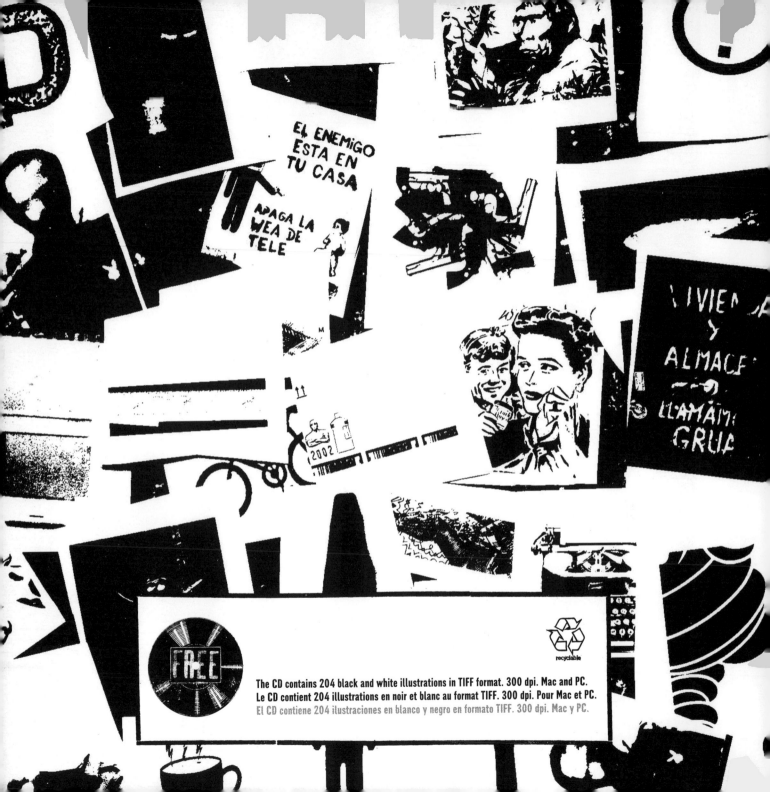

EL ENEMIGO
ESTA EN
TU CASA

APAGA LA
WEA DE
TELE

2002

FREE

The CD contains 204 black and white illustrations in TIFF format. 300 dpi. Mac and PC.
Le CD contient 204 illustrations en noir et blanc au format TIFF. 300 dpi. Pour Mac et PC.
El CD contiene 204 ilustraciones en blanco y negro en formato TIFF. 300 dpi. Mac y PC.

recyclable